Be a
Polymer Clay
PRO!

15 Projects &
20+ Skill-Building Techniques

LAUREN TOMLINSON

stashBOOKS.
an imprint of C&T Publishing

Text copyright © 2023 by Lauren Tomlinson

Photography paid for by C&T Publishing, Inc. copyright © 2023 by C&T Publishing, Inc.

Photography paid for or created by Lauren Tomlinson copyright © 2023 by Lauren Tomlinson

Publisher: Amy Barrett-Daffin

Creative Director: Gailen Runge

Senior Editor: Roxane Cerda

Editor: Madison Moore

Cover/Book Designer: April Mostek

Production Coordinators: Zinnia Heinzmann and Tim Manibusan

Photography Coordinator: Lauren Herberg

Photography Assistant: Rachel Ackley

Front cover photography by Paula Shoultz

Instructional photography by Lauren Tomlinson

Subjects and lifestyle photography by Anne McGrath

Published by Stash Books, an imprint of C&T Publishing, Inc., P.O. Box 1456, Lafayette, CA 94549

Attention Teachers: C&T Publishing, Inc., encourages the use of our books as texts for teaching. You can find lesson plans for many of our titles at ctpub.com or contact us at ctinfo@ctpub.com.

We take great care to ensure that the information included in our products is accurate and presented in good faith, but no warranty is provided, nor are results guaranteed. Having no control over the choices of materials or procedures used, neither the author nor C&T Publishing, Inc., shall have any liability to any person or entity with respect to any loss or damage caused directly or indirectly by the information contained in this book. For your convenience, we post an up-to-date listing of corrections on our website (ctpub.com). If a correction is not already noted, please contact our customer service department at ctinfo@ctpub.com or P.O. Box 1456, Lafayette, CA 94549.

Trademark (™) and registered trademark (®) names are used throughout this book. Rather than use the symbols with every occurrence of a trademark or registered trademark name, we are using the names only in the editorial fashion and to the benefit of the owner, with no intention of infringement.

Library of Congress Cataloging-in-Publication Data

Names: Tomlinson, Lauren, author.
Title: Be a polymer clay pro! : 15 projects & 20+ skill-building techniques / Lauren Tomlinson.
Description: Lafayette, CA : Stash Books, an imprint of C&T Publishing, Inc., [2023] | Includes index. | Summary: "Veteran clay artist Lauren Tomlinson walks readers through all the polymer clay basics with tips and troubleshooting to ensure success. Readers will find detailed instructions on techniques such as creating slab designs, sculpting, and molding and 15 projects to get them started - everything from jewelry to home decor"-- Provided by publisher.
Identifiers: LCCN 2022036251 | ISBN 9781644032466 (trade paperback) | ISBN 9781644032473 (ebook)
Subjects: LCSH: Polymer clay craft. | House furnishings. | Plastic jewelry.
Classification: LCC TT297 .T66 2023 | DDC 745.57/23--dc23/eng/20220819
LC record available at https://lccn.loc.gov/2022036251

Printed in the USA

10 9 8 7 6 5 4 3 2 1

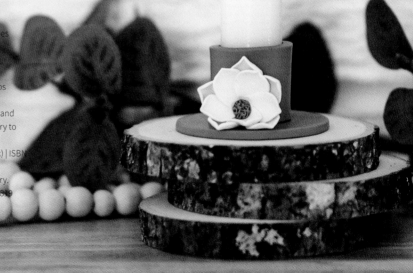

Dedication

To my incredible siblings who encouraged me and cheered me on for so many years. Thank you for believing in me before I believed in myself.

Acknowledgments

Thank you Lauryn Walsh for sharing your clay book with me all those years ago!

Contents

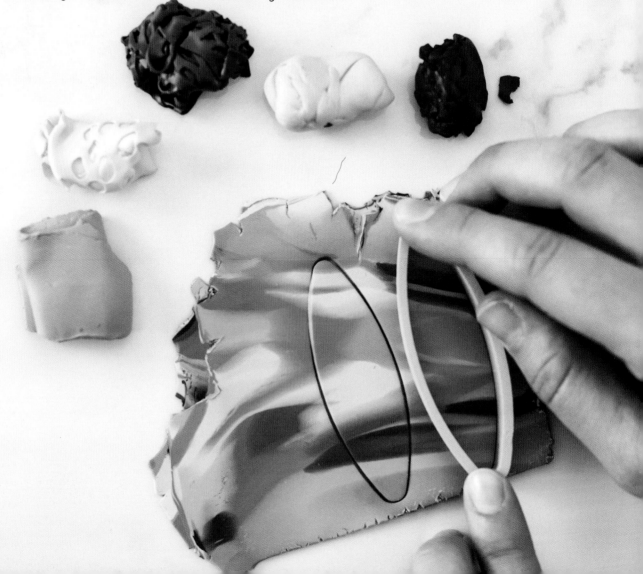

BASICS 6

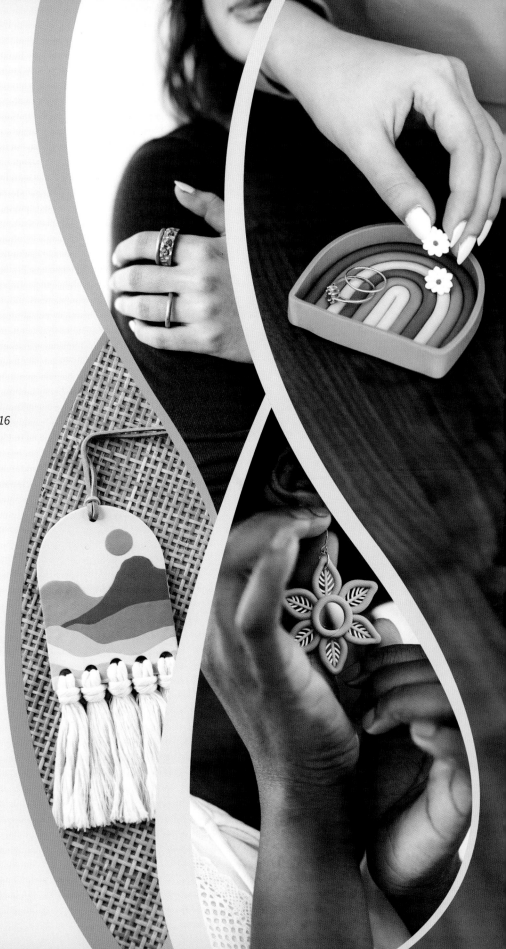

BASICS

In this section, you'll learn all the techniques, tools, and materials that you'll need to make your first polymer clay project!.

Introduction to Polymer Clay
7

Tools
14

Finishing Products
22

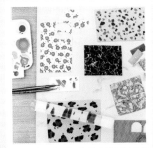

Slab Designs
32

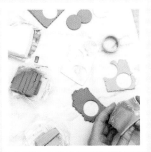

Color Mixing
38

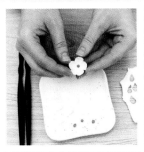

Sculpting
41

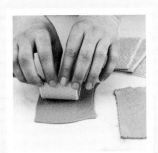

Imprinting
48

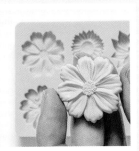

Molds
51

Using Scraps
55

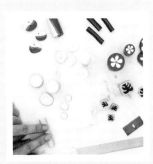

Making Canes
58

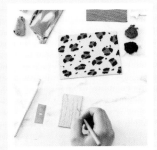

Creating Patterns
64

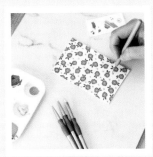

Painting Polymer Clay
76

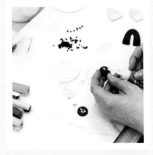

Adding Extra Elements
81

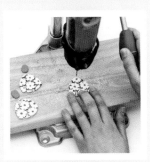

Techniques for Finishing
84

Introduction to Polymer Clay

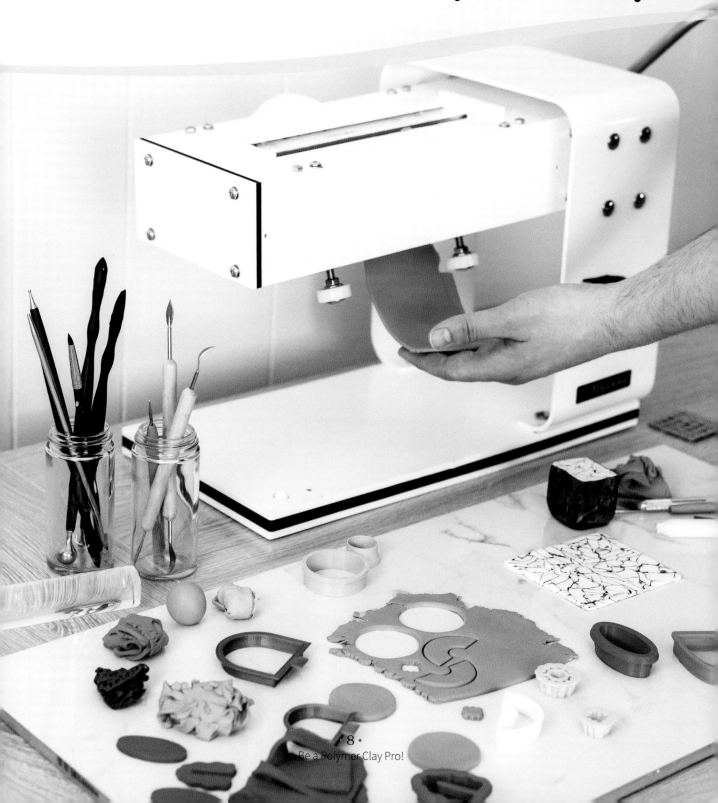

Polymer clay is a man-made modeling clay made of polyvinyl chloride, better known as PVC. It is soft and malleable until safely baked at a low temperature (275°F) in your home oven or toaster oven. After baking, it becomes hard but flexible plastic. It is a beautifully versatile medium that began as a craft for kids but that can now be found as part of works in major museums.

Clay Brands

Now that you know what it is, which brand should you choose? There is no right or wrong answer to this question; it truly comes down to preference! Each brand has its own look, feel, and characteristics. Some brands work for every project, and some are better suited for specific projects. The more you use and experiment with different brands, the easier it will be to narrow down your favorites.

The clay I use for the projects in this book are Fimo, Premo, Sculpey Soufflé, and Cernit. Together they come in a massive range of colors and have a variety of finishes when baked. Each of these brands is very strong after baking, if baked properly; your finished project will hold up beautifully to ongoing use.

PRO TIP You can mix all the clay brands together. This allows you to create custom colors and develop a custom look and feel to your clay.

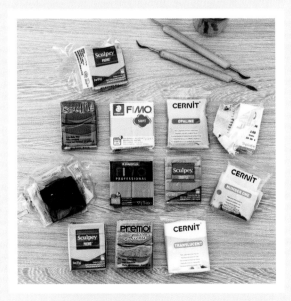

Fimo can be very crumbly and hard to work with right out of the package, but I promise with a little bit of time, patience, and conditioning, it will come together (we'll get to conditioning soon).

Premo is a well-loved brand that has a wide range of colors and effects. I've always found that it bubbles a bit more than other brands, but it's great when mixed with a different clay. I usually choose Sculpey Soufflé for mixing with Premo.

Sculpey Soufflé is one of the easiest clays to use! It typically needs little to no conditioning, so it can be used straight out of the package. It's also the least prone to bubbles, making it a great clay to use on its own or mix into other brands.

Cernit is a strong, gorgeous clay that has more of a porcelain finish. Cernit also has my favorite line of translucent clays.

WHAT NOT TO USE

I always feel there should be a warning about **SculpeyIII** clay, so I'm giving one. It is one of the most widely recognized brands, comes in many beautiful colors, and is one of the easiest clays to find. However, it is best suited for kids' crafts. No matter how long you bake it, it will remain weak and brittle.

If you already have a stash of it and don't want it to go to waste, there are a few things you can do with it. It can be used to create something thick like a candle holder; the thicker your project is, the harder it will be to break. You also can layer or mix SculpeyIII with a stronger brand or use it to prototype new designs. I personally never use this brand and wouldn't recommend purchasing it.

Conditioning Your Clay

Some clay can be used easily straight from the package, but most will need to be worked with your hands for a bit before they are soft enough to use. Warming up your clay to make it workable is called conditioning. You can warm it up by kneading it with your hands or by running it through a pasta machine several times. While conditioning, you want to introduce as little air as possible; this will reduce the amount of bubbles in your finished project.

Using a pasta machine is the easiest way to condition, and it eliminates the most bubbles. Run your clay through the pasta machine at the thickest setting, fold it in half, and run it through again. Rotate the clay so that the folded seam goes through on the side, which ensures air doesn't get trapped between the folds. If you see bubbles as you roll out your clay, use a blade or needle tool to slice or poke them as you continue to condition.

Some clays are more crumbly than others and are harder to condition. Instead of trying to condition a huge pile of crumbly clay, I like to start with a small portion and slowly work in the rest as I go. This works especially well for Fimo. If your clay just won't come together, you can add a few drops of clay softener and continue mixing.

PRO TIP On the other hand, if your clay is too soft and sticky, you can leach some of the oil out of it by sandwiching it between two pieces of cardstock, placing something heavy on top, and letting it sit. The paper will absorb some of the oil, making it less sticky.

Once your clay is soft and easy to manipulate, you're ready to start creating!

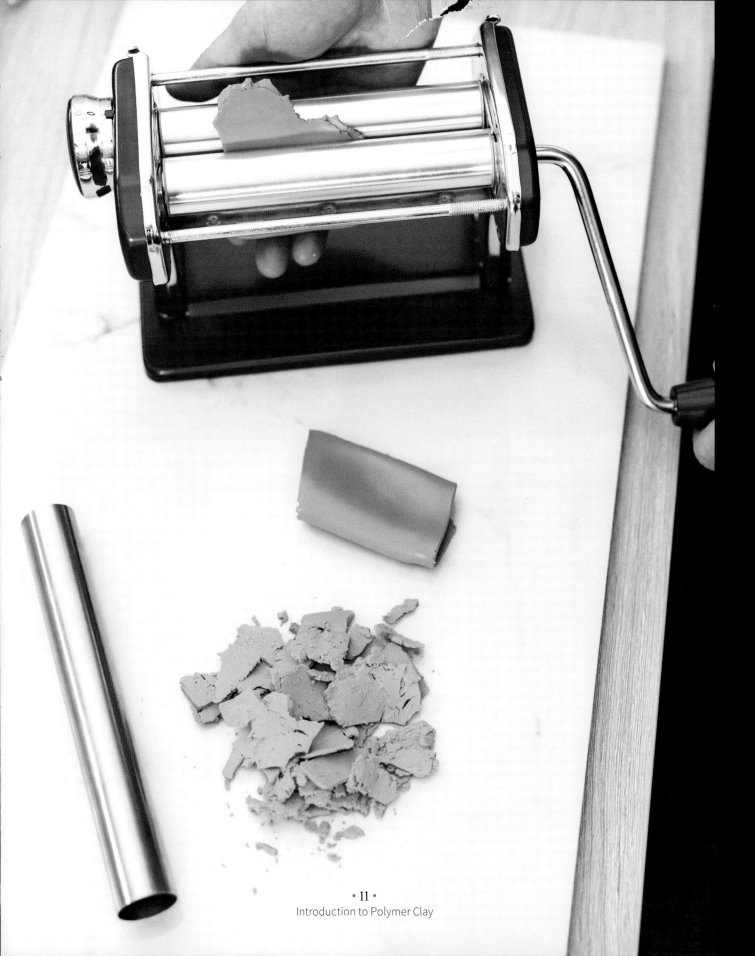

Introduction to Polymer Clay

Baking Surfaces

Because you are baking your clay at such a low temperature, you can use any oven-safe surface when baking. Tile, tin, glass, and pizza stone are all popular choices. You can even bake on cardstock or cardboard. Be aware that if you bake on a shiny surface, like glass, your clay will get shiny spots wherever it is touching that surface. I personally prefer baking on a pizza stone to avoid this, but any of these options will work, and you just need to find what works best for you.

PRO TIP Tenting your project with cardboard will help keep a consistent temperature on your pieces and prevent any scorching. I use a cardboard box top that is a couple inches deep. Place the cardboard over the piece and on top of your baking surface.

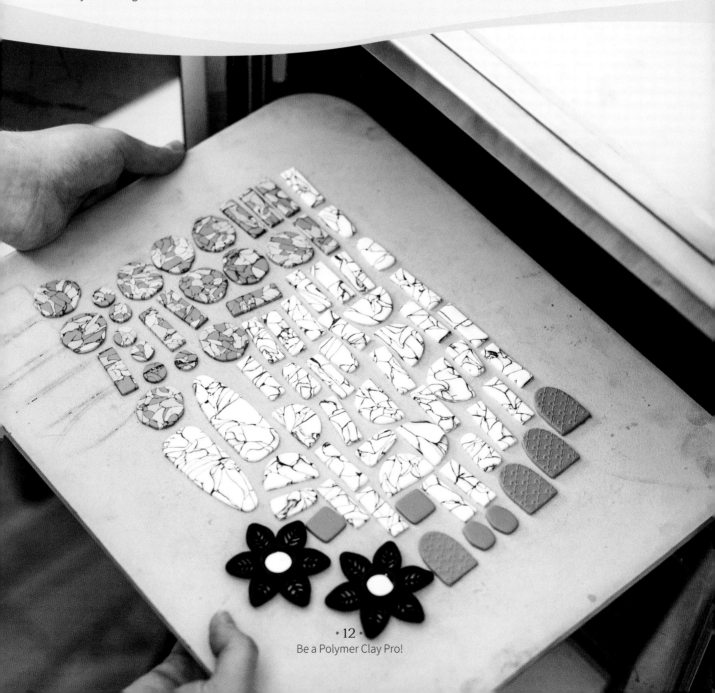

Ovens

You can safely use your home oven or a toaster oven to bake clay. But not all ovens are created equal. When baking food, your oven temperature can fluctuate without it ruining your recipe. That's not the case with clay. If your temperature is too high, you can scorch and discolor your piece. Too low, and your clay will remain weak and brittle. So an oven thermometer is an essential tool.

You can set your oven to 275°F, but more than likely, that's not exactly accurate. Every oven is different, and you should always run some tests before risking a project you worked hard on. My oven needs to be set at only 260°F to reach 275°F, but someone I know with the same oven needs hers set right at 275°F.

Place your rack in the middle of your oven, put an oven thermometer on your baking surface with a piece of raw clay, and bake. While baking, compare the temperature on the thermometer with the temperature you set the oven to. Test the flexibility of the clay, and note if there is any major discoloration. Adjust your oven until you find the correct temperature. Your clay should be slightly flexible and have no brown tinge to it.

Always double-check the temperature before baking clay. If you're using a toaster oven, look for one that allows you to control the temperature to the smallest degree. My old toaster oven went up 25° at a time, so I could never get a consistent bake for my pieces. The one I use now goes up 5° at a time, which allows me to always get a consistent bake.

275°F is typically the ideal temperature you want to hit. If you are mixing clays that have drastically different temperatures listed, you can start experimenting by beginning with the lower temperature or splitting the difference between the two. Spending extra time running tests on your oven in the beginning will save

you time and frustration in the long run. You can't dive in and explore your creativity if you're constantly worried about the integrity of your pieces while they're in the oven.

PRO TIP Use strips of white and translucent clay from various brands to test your oven. This will most clearly show you at what temperature your oven begins to scorch and discolor clay.

Time and Temperature

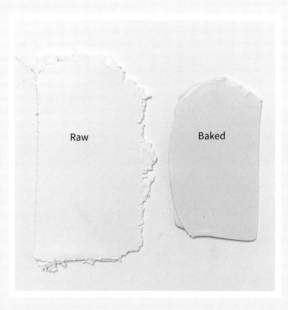

Raw

Baked

The clay package will tell you that you need to bake the clay for only 15–30 minutes, but I promise you that that's not enough time! If you're baking something thin, like jewelry, you need a minimum of 45 minutes. I usually bake jewelry for 50–60 minutes, and I always preheat the oven for 15 minutes before putting the pieces in. If you're baking something thicker and larger, like home decor, it will take even longer. I bake a trinket dish or a large wall hanging for 90–120 minutes. With the correct temperature settings on your oven, you can bake your projects for as long as you want without burning them.

Tools

My Most-Used Tools

These tools are always within reach and are used every time I sit down to create: needle tool, knitting needles, ball stylus (also called an embossing stylus), rubber-tipped sculpting tools, roller, various sized blades, Q-tips, PAC-PEN, and rubbing alcohol.

I use these tools for shaping, smoothing, and adding texture and small details to my projects. A PAC-PEN is hands down my favorite tool! It's a small pen-like tool with interchangeable tips that will cut out tiny shapes for small detail work.

Work Surfaces

In general, when using your clay, work on a smooth, nonporous surface. Anything with a texture will make it impossible for you to cleanly remove a project. Some popular options are tile, glass, or a glass cutting board. I've used all of these great choices. Avoid plastic and wood surfaces. Not only will the clay stick to them, but the blades you use while creating will cut up the surface.

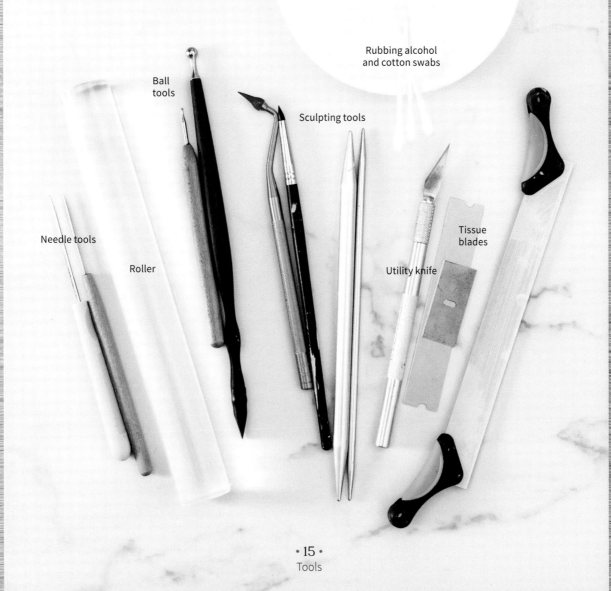

Ball tools

Rubbing alcohol and cotton swabs

Sculpting tools

Needle tools

Roller

Tissue blades

Utility knife

Rolling Tools and Depth Guides

A pasta machine is the best and easiest way to roll out and condition clay. But even if you have a pasta machine, you also need a roller. There are rollers made specifically for polymer clay. They're thinner and shorter than rolling pins for baking, making them easier to maneuver. Polymer clay rollers are typically made from acrylic or stainless steel.

If you don't have a pasta machine, I recommend using depth guides with a roller to get all of the clay to the same thickness. Depth guides are two long ruler-like tools that lay flat on the work surface or rings that go on the ends of a rolling pin. Place the two depth guides down on your work surface with clay in between, place the edges of your roller on the guides, and roll until the clay is even with the guides.

PRO TIP You can make your own depth guides by gluing extra-large popsicle sticks together, by using matching pieces of scrap wood, or even by using your own scrap clay.

Shape Cutters

Cutters are usually made of metal or 3D-printed plastic. Cutting out shapes from the clay is just like cutting out cookie dough. In fact, before polymer clay became so popular, and before 3D printing was around, cookie cutters or fondant tools were the only things available. Now there are hundreds of businesses that create cutters just for polymer clay! When searching for cutters, both cookie cutters and clay cutters will pop up. There's nothing wrong with using 3D-printed cookie cutters for your clay, but be aware that they most likely will be much larger than you need, and the edges will not be as sharp. Clay is stiffer than dough, so a clay cutter is designed with a sharper edge, leaving you with less cleanup and sanding to do at the end of your project.

The technique for using any kind of cutter is the same. Roll out a slab of clay, and then push the cutter down with equal pressure until you've cut all the way through the clay. Both kinds of cutters will leave small notches or faint lines on the sides of your pieces. Smooth these out with your fingers or with a tool before baking; it will save you lots of sanding time at the end.

Clay will probably stick to the work surface after you cut out a shape. Some cutters have a lot of corners and lines in which the clay can easily get stuck. So use your finger to gently pop the shape out, or dust the surface of your clay with cornstarch before cutting for nonstick removal. In addition, try lifting the cut piece from the surface with a tissue blade to stop the project from warping.

The thickness of the clay when using cutters is totally a preference. It also can depend on the project. Typically, for my base, I start with a 2mm thickness. If I know I'm going to add layers on top, or if I'm adding resin at the end, I start a little thinner. If I'm working on a home decor project, I'll roll the clay out thicker to add some sturdiness to it.

PRO TIP There are thousands of cutters you can purchase and endless possibilities for mixing and matching them. Before you drown in the sea of options, purchase the basic shapes. They're a good, solid foundation to build on, and they are incredibly versatile. After you cut out a shape with your cutter, you can continue to slice it any way you want. Endless possibilities!

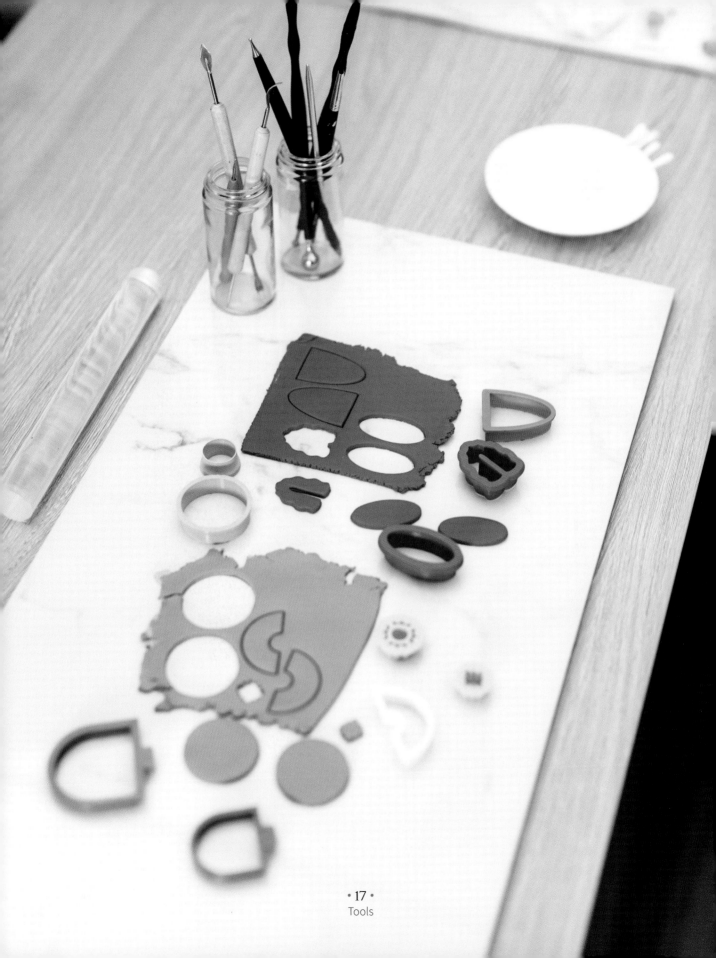

Cutting Tools

You'll need cutting tools for cutting your clay and lifting projects off the work surface without distorting them. The most useful blades are tissue blades (thin blades available in craft stores or on clay sites) and small box cutters. I find it helpful to have a variety of lengths on hand. You're also going to want a craft knife, like an X-Acto blade, for freehand cutting and tiny details. Finally, don't forget a PAC-PEN!

PRO TIP Get a small knife sharpener to keep your blades nice and sharp at all times.

HAND CUTTING SHAPES

All you need to create shapes in your clay is a craft knife! This gives you freedom beyond what cutters can offer. You can cut freehand or draw a design on paper first to guide you. The trick is to hold your knife as upright as possible while you cut to get a clean edge. Craft knives are also great for cutting out tiny details like leaves and petals if you don't have a cutter that's small enough.

Hand cutting your designs will take a little longer, but it allows you to create a design completely unique to you.

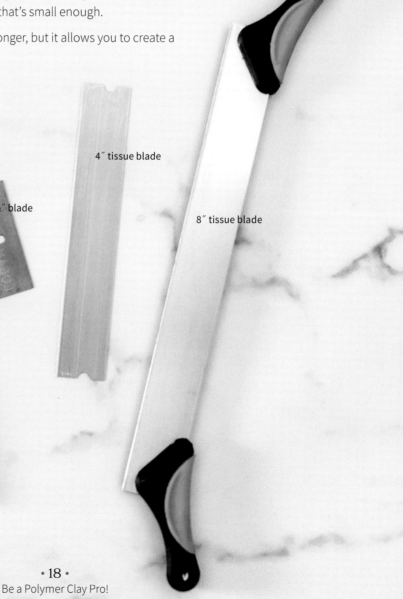

4″ tissue blade

1½″ blade

Craft knife

8″ tissue blade

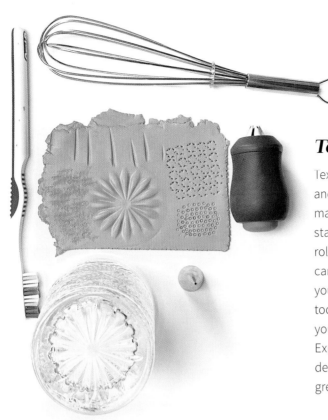

Texture Tools

Texture tools are an easy, fun way to add texture and dimension to your projects, and there are many made just for polymer clay. Rubber texture mats, stamps, stencils, needle tools, small comb tools, and rollers are some of the most common. However, you can use anything and everything to add texture to your clay. Don't limit yourself to made-for-polymer tools. Look around your home, and gather anything you think might leave a cool impression in your clay. Explore different aisles in your craft store—the cake decorating aisle and the leather goods aisle are great places to start.

Extruder

An extruder is a tool that forces clay into a long, even cylinder of one shape. An extruder usually comprises a hollow metal tube with a hand crank press at one end and shaped disks at the other. Several brands carry extruders, but my favorite is carried by the Lucy Clay brand. However, it is quite pricey, and the Walnut Hollow extruder is popular at a significantly lower price. You can purchase extruder disks from multiple brands; they will fit in almost any extruder.

You want to make sure the clay is soft and conditioned before loading your extruder; otherwise the clay will be extremely hard to crank out, and it will crack as you use it. I use the shapes I extrude to create three-dimensional patterns and add dimension to a plain slab of clay. You can mimic knit, fringe, and corduroy patterns, to name a few. It's also one way of creating hoop earrings that are even and consistent every time.

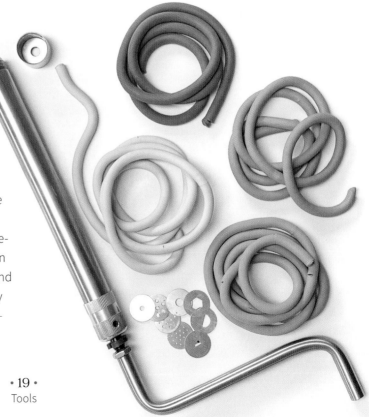

The Most Important Tool

Your hands! With practice over time, you'll learn the pressure and movements needed for working with polymer clay. You'll learn when to be gentle and when a more firm pressure is called for. Shaping, smoothing, holding, twisting, and turning—your hands will do it all! Don't give up if your first try doesn't look as smooth and clean as ones you see in this book or online. Your hands are just starting to learn about the clay, and only time, patience, and practice will help you improve.

Findings and Jewelry Tools

Findings are the metal bits and pieces you will add to your clay to make jewelry. Type *jewelry findings* into any search engine, and you will be instantly overwhelmed with results. Not knowing where to start or what certain items you're searching for are called can get frustrating very quickly.

To break it down a little, we'll most often be using earring posts, jump rings, and charms. Most popular earring post sizes are 6mm, 8mm, 10mm, and 12mm. The size you want will depend on the size of the clay piece on top. If your piece is bigger or heavier, you'll need a larger size. I use 8mm and 10mm most often, but all four of these sizes are common.

Jump rings are rings that can be opened and closed to connect two pieces. Size is a matter of preference. Some people like their pieces to be close and tight together, while others prefer their pieces to swing and dangle more. I use 8mm jump rings most frequently, but I like to have 6–10mm on hand for the occasional project. Look for tarnish-resistant jump rings with an 18mm gage, which refers to the ring's thickness. An 18mm gage is strong enough to weather everyday use while still being flexible enough to open easily with pliers.

You also want to think about which metal to choose. Many people, including me, are sensitive or allergic to certain metals. I go for titanium, surgical stainless steel, or gold plated. Gold filled is a great option but will come at a much higher price point.

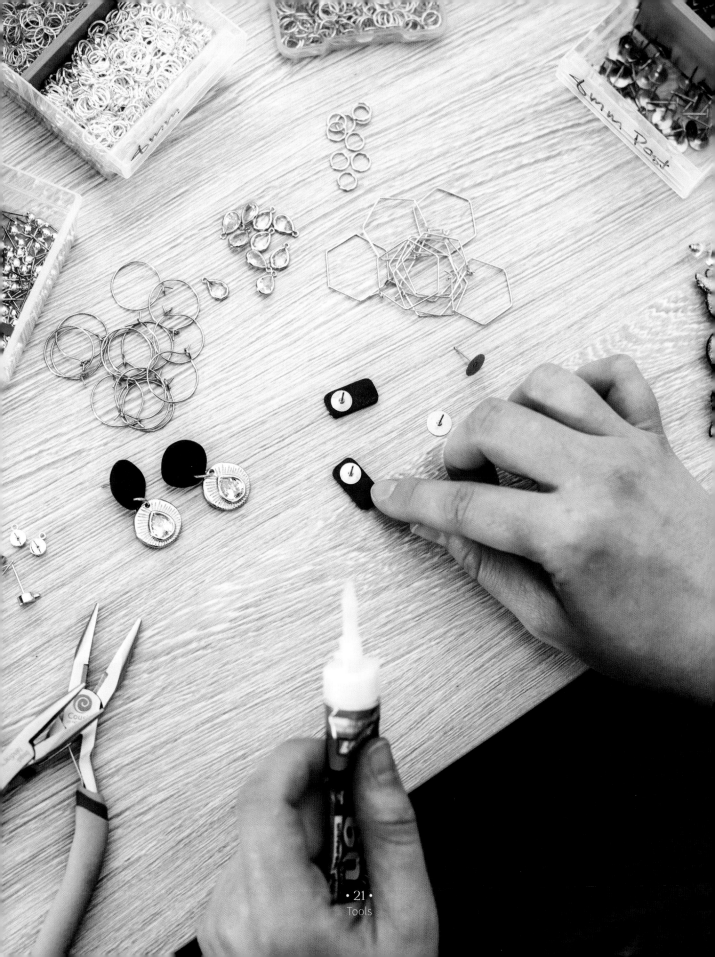

Finishing Products

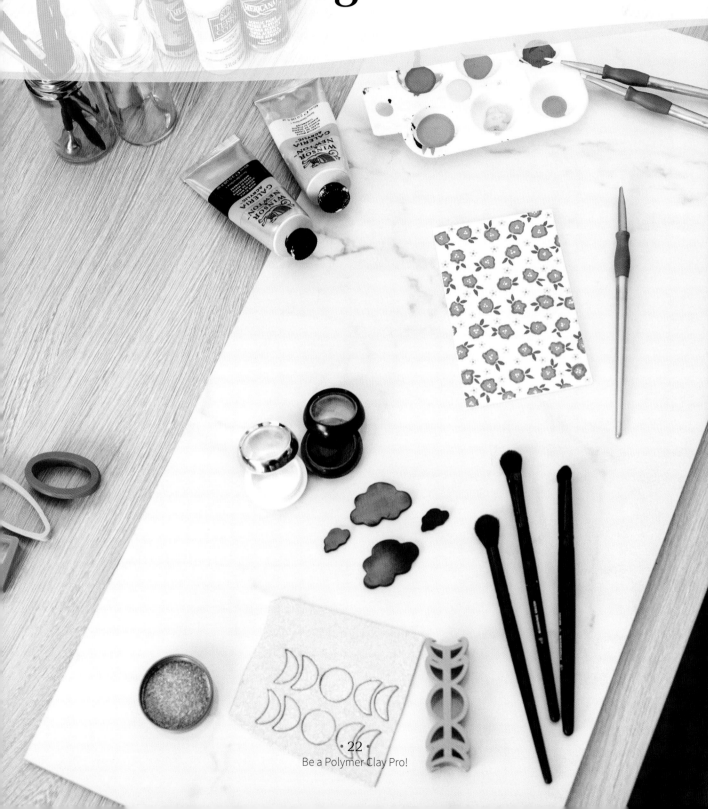

Be a Polymer Clay Pro!

A lot of things can be added on top of clay before and after you bake it to enhance your designs. For more about how to use many of these supplies, see Adding Extra Elements (page 81) and Techniques for Finishing (page 84).

Glitter

Glitter is a beautiful and simple way to add some fun sparkle to your projects. It's as easy as brushing it on or mixing it into your clay for a speckled look. When you add glitter on top of raw clay, you must bake it and then seal it; otherwise you're in danger of its rubbing off. Resin is a popular way of sealing glitter because it adds some extra shine and sparkle. If you have a baked piece you want to add glitter to, mix the glitter into some resin, and coat the top of the clay with both. Sealing with resin will work best on flat designs. For more information, see Resin (page 26). When the glitter is added into the raw clay, there is no need to seal the piece.

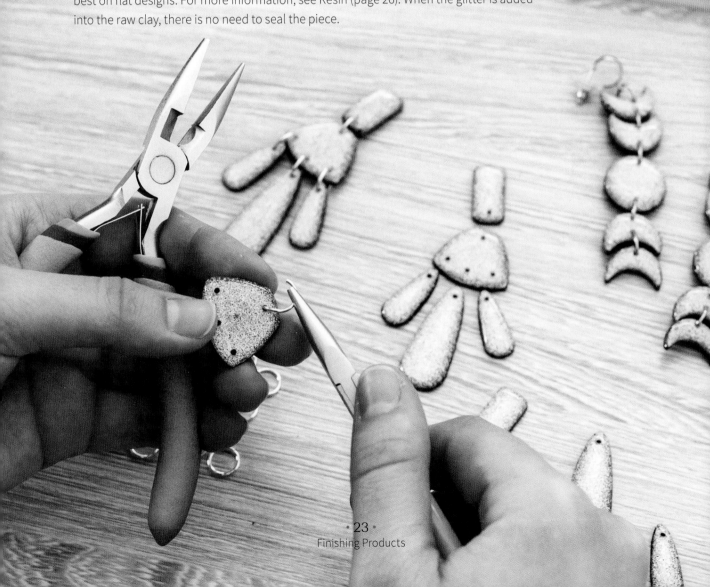

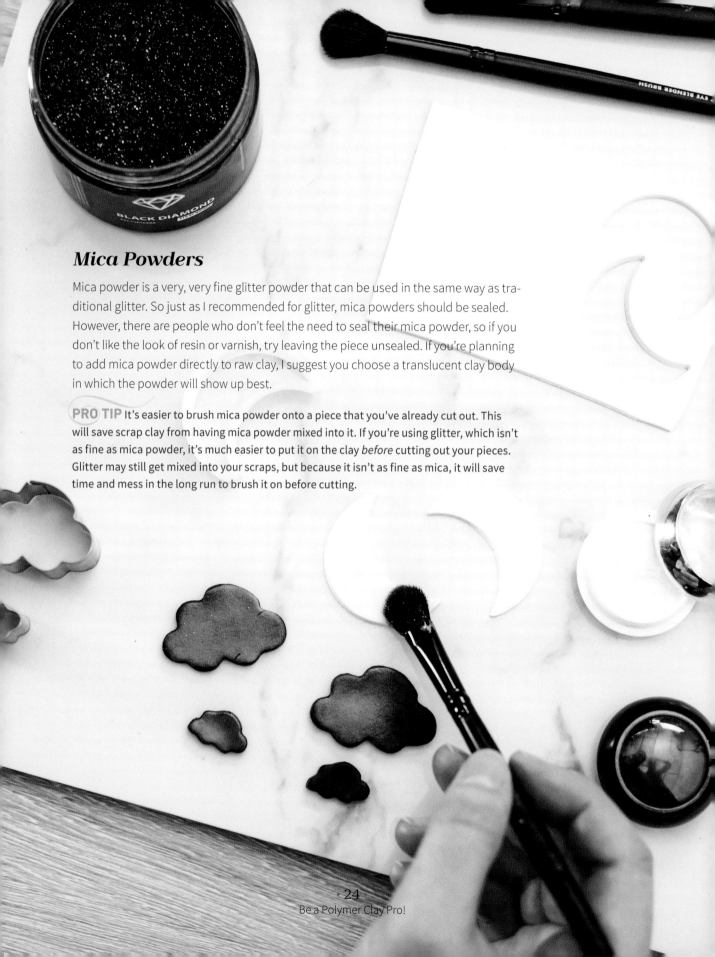

Mica Powders

Mica powder is a very, very fine glitter powder that can be used in the same way as traditional glitter. So just as I recommended for glitter, mica powders should be sealed. However, there are people who don't feel the need to seal their mica powder, so if you don't like the look of resin or varnish, try leaving the piece unsealed. If you're planning to add mica powder directly to raw clay, I suggest you choose a translucent clay body in which the powder will show up best.

PRO TIP It's easier to brush mica powder onto a piece that you've already cut out. This will save scrap clay from having mica powder mixed into it. If you're using glitter, which isn't as fine as mica powder, it's much easier to put it on the clay *before* cutting out your pieces. Glitter may still get mixed into your scraps, but because it isn't as fine as mica, it will save time and mess in the long run to brush it on before cutting.

Painting Supplies

Acrylic paint is the paint most compatible with polymer clay. You can use it to paint any part of your clay before *or* after baking. You can freehand your design using any kind of brush or use a silk-screen stencil. Usually, there is no need to seal the paint. It bonds well with the clay.

However, if you find that it easily scratches off, you can heat set it or apply varnish or resin. To heat set paint added after baking, set your oven to your normal clay-baking temperature and rebake your painted pieces for 20–30 minutes.

Other paint types can be used with polymer clay, but they all act differently, and some will react poorly. Always make a test piece, and monitor it for several weeks or months when trying a new paint. Keep an eye out to see if the piece becomes sticky, the piece fades, or the clay breaks down. This indicates the paint is not compatible with polymer clay.

Polishing

Polymer clay is matte after baking. However, you can give it a glass-like shine with a little sanding and polishing. This will work only for clay-only designs. If you have added paint, glitter, or mica powder, polishing will just remove those finishing products. This also will not work with the Soufflé clay brand (it will leave white marks on the clay that you can't smooth out), but it will work well with every other brand mentioned in this book. It takes time and patience, but you will love the results!

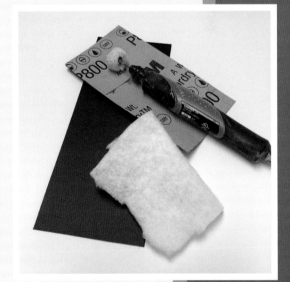

Starting with 400-grit wet/dry sandpaper, sand the clay. Then move up to 600 grit, and then finally to 800 grit. Move from one grit level to another after only a minute or so; you want it to feel a little smoother between each level until it's completely smooth after the 800 grit. Once the piece is completely smooth, rub it with a cloth until it shines, or use a polishing head on a Dremel to finish it up.

Resin

Resin adds a beautiful, glass-like finish to a piece. There are two kinds of resin that we will cover in this section: two-part epoxy resin and UV resin. Resin is toxic, so for either option, you must take the proper precautions! Each brand is a little different and has its own instructions and warning label. You *must* read them carefully and follow all recommendations for safe use. I also recommend the following:

• Use gloves and a full face respirator mask while working with resin.

• Avoid letting resin touch your skin.

• Watch for expired resin. If it appears yellow in the bottle, it's too old to use.

An important note about resin: All resin will eventually yellow. No matter what you do, it will, over time, develop a yellow tinge. If you're worried about this, consider polishing your eligible pieces instead of sealing them with resin.

EPOXY RESIN

I use ArtResin, a two-part epoxy resin. I choose to work with a two-part resin rather than a UV resin because it doesn't yellow as quickly as UV resin; it's more durable; and despite its taking longer, two-part epoxy has a more reliable cure.

Epoxy resin comes in two parts that you mix together, usually at a 1:1 ratio. After mixing the two parts, you have 30–40 minutes to coat your pieces before the resin starts to thicken. I like to use a syringe to pour resin on my pieces because it allows me to control the flow easily, and then I guide it with a bamboo skewer to cover the whole piece.

As it dries, resin has a tendency to pull away from corners and edges, so once you're done pouring the resin on all your pieces, go back through with a bamboo skewer again, and gently push the resin to cover all the edges. Remove bubbles before the resin cures by using a butane torch or lighter to heat up the bubbles until they pop. Do not get the flame too close to the resin, and keep it constantly in motion. I move it in small circles as I pass over the bubbles.

Epoxy resin will fully cure in 24–48 hours. It's best to cover your pieces while they cure so no stray piece of dust ruins the project.

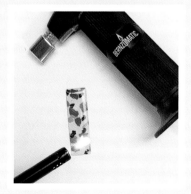

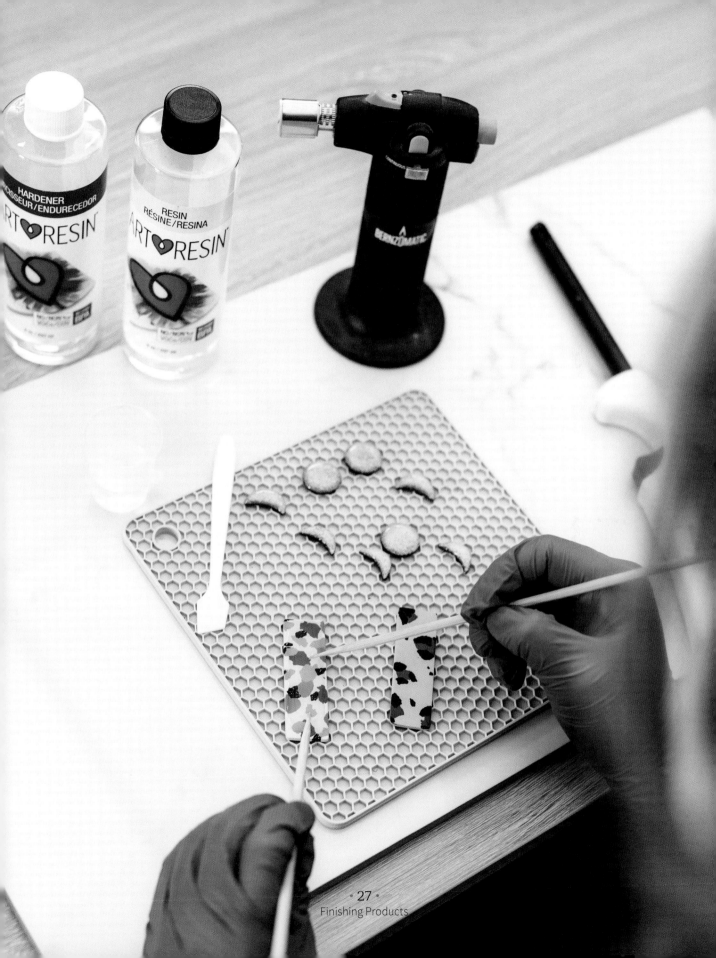

UV RESIN

UV resin is much easier and faster to use. You can cure it with a UV lamp or in the sun. Many people like to secure their earring posts to the clay with UV resin. No matter how you're using it, pour the resin on, spread it to all the edges with a bamboo skewer, and then cure it under a UV lamp. The package will tell you how long it needs to cure, but if it feels sticky, you haven't cured it for long enough. You also can start it under a lamp and then set it out in the sun to fully cure.

As I mentioned, I prefer using two-part epoxy for coating the front of a piece, but if I were making earrings, I would definitely use UV rather than epoxy for securing posts on the back.

PRO TIP If you're going to be finishing your project with resin, roll out your base clay thinner than you normally would. Resin adds some thickness, and you want to keep your pieces from being too thick and bulky.

Varnish

Varnish is a sealant or coating for use after baking. It's similar to resin, but varnish comes in many finishes, from matte to glossy. If you're looking for a thick shiny layer, you'll want to go with resin, but varnishes allow you to explore a wider variety of looks.

Not all varnishes work well with polymer clay. Some look fine at first but over time react poorly and cause the clay to feel sticky. Many clay brands have their own line of varnishes, which are the safest choices. My favorite matte sealant is from the Cernit line. Always check the labels for safety information, but in general, varnishes are safe to use without gloves or masks.

Apply thin layers of varnish with a paintbrush, letting each layer dry before applying the next. If you try to apply a thick layer, it can pool in one spot and dry unevenly.

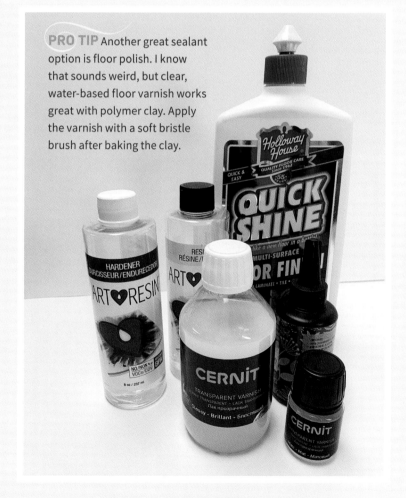

PRO TIP Another great sealant option is floor polish. I know that sounds weird, but clear, water-based floor varnish works great with polymer clay. Apply the varnish with a soft bristle brush after baking the clay.

More Additions

As long as they are oven safe, you can add the following items to your projects before baking.

BRASS CHARMS

Brass charms are a beautiful and popular way to add a little something to your designs. Search *brass finding* online, and you will get thousands of cute results. You can imbed them in your clay by sandwiching them between two pieces, or you can attach them with jump rings when assembling a finished piece.

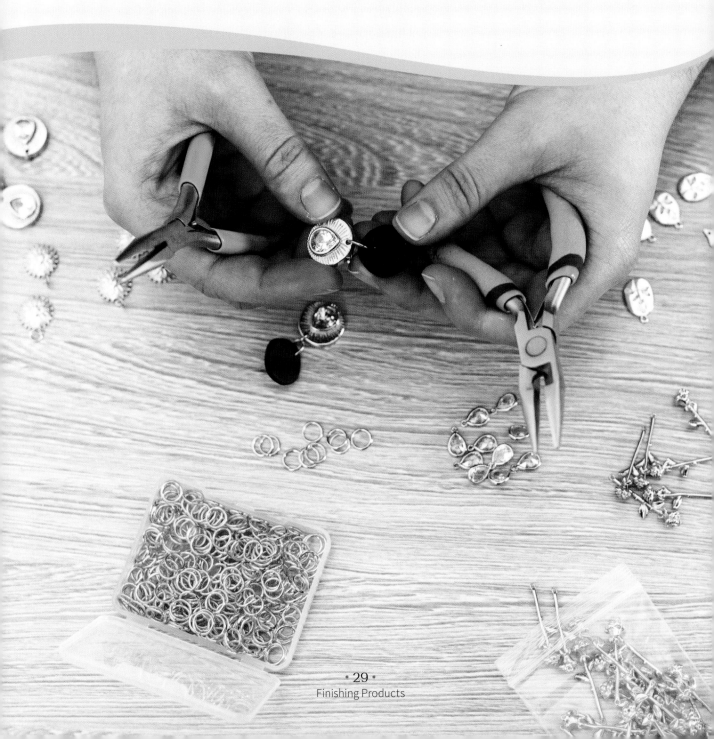

CRYSTALS

Decorative rocks or crystals need to be embedded or glued to your pieces. They can be baked right along with your clay but will fall out or off later if you don't embed or glue them down. For more in-depth information about attaching outside objects, see Adding Extra Elements (page 81).

METAL LEAF

Metal leaf can add a beautiful metallic shine to polymer clay. You can apply it on top of your piece or mix it into the clay. If it's mixed into the clay, there's no need to seal it. If it's placed on top, it will stick to raw clay but will peel off after baking. So, seal it with either varnish or resin. Some people have noted that it may tarnish over time, but I have pieces with gold leaf that are several years old and are just as shiny as when I first made them.

PRO TIP When adding extras to clay, have some kind of design in mind before you make a purchase. There are so many cool choices out there, and it's very tempting to get them all. But if you don't have a specific design in mind, they will just be looking cool in a forgotten drawer. Save yourself the space and the money by working out a design before you start collecting and buying all the things. This is especially true for brass charms!

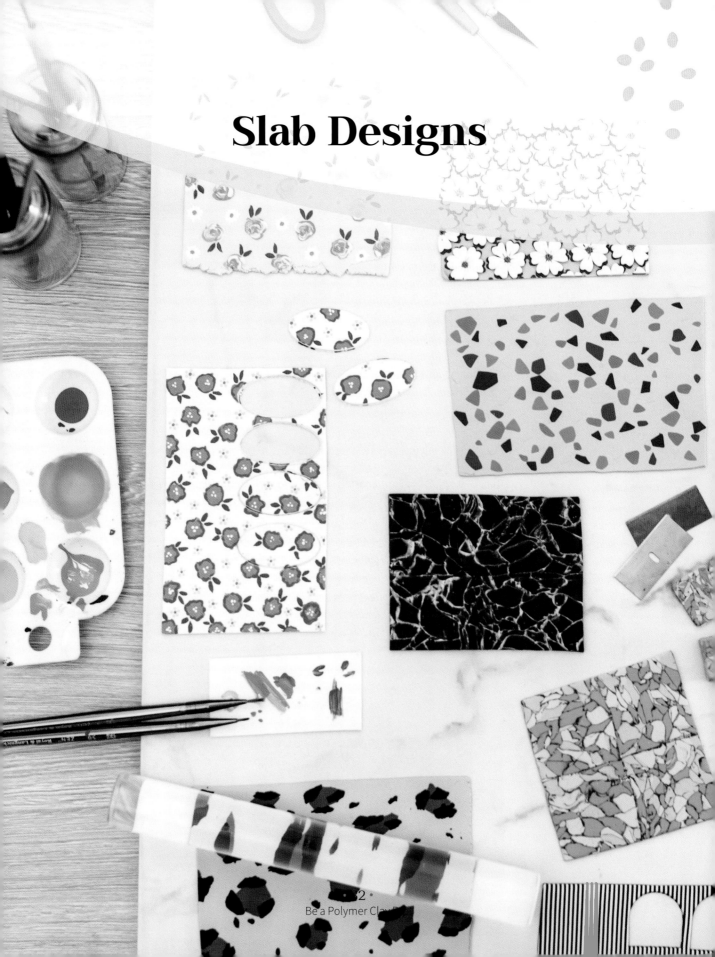

Slab Designs

Slabs are large designs that can be cut up into multiple projects. You can make any kind of pattern, use multiple texturing techniques for flat designs, or layer clay to create a three-dimensional look. When working with slabs, you need to think in layers. Think about what you want at the forefront of your design, and what edges you want to hide behind other layers of clay. Let's learn about the different kinds of slabs and then make one of each kind!

Three-Dimensional Slab

Three-dimensional slabs have three-dimensional elements that sit on top of a base layer of clay. When creating a raised design, the thickness of each layer is very important. Start with a thinner base. I like to plan ahead by deciding what to put on each layer and then work one layer at a time. Raw clay will stick to itself, so lightly pressing your design pieces onto the clay base will make your three-dimensional elements stick. If you're worried that they may fall off, you can use a small drop of liquid clay under all the little pieces.

PRO TIP Clean up the edges of petals, leaves, and other pieces before placing them on your slab to give your finished pieces a cleaner, polished look. There's no way to fix them up after baking!

Flat Slab

In a flat slab, all additional elements are rolled flat into the main base slab. But even though there are no raised elements, you still need to consider the thickness of the layers. If the layers are too thick when you start to roll the slab, the design will get distorted and blobby. I roll all of the top layer clay as thin as possible before placing it on top of the main slab. As you roll the slab flat, the designs will slightly increase in size. So cut the top layer pieces a little smaller than you want them to end up.

Use a roller and depth guides, not a pasta machine, for flattening a 2D slab design. A pasta machine will distort and stretch your design too much. A design like terrazzo doesn't need to be very precise, so a little distortion and stretching won't make a big difference. But for some designs, it will really matter.

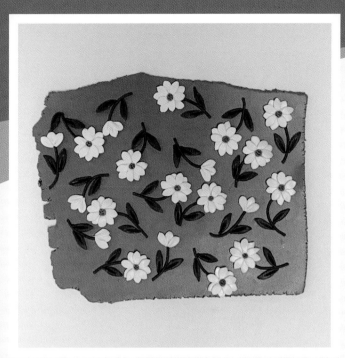

FLOWER THREE-DIMENSIONAL SLAB

For this project, I recommend using an extruder for the stem and small cutters or a PAC-PEN for leaves and petals. For information about forming these shapes by hand, see Flowers (page 44). Three-dimensional slabs can be trickier than flat slabs, so be patient, and keep trying!

Prepare Each Layer

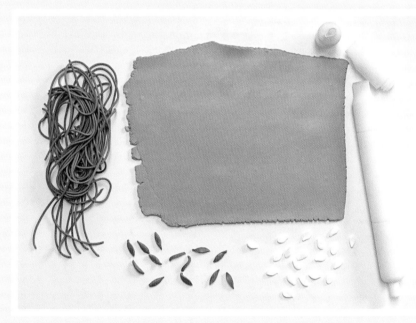

MATERIALS

Polymer clay in blue, green, white, and yellow

Roller and depth guides **or** a pasta machine

Extruder

PAC-PEN with petal/leaf tip

Needle tool

Small ball stylus tool

Roll out the blue piece of clay to 1.5mm depth using a roller and depth guides or a pasta machine. Insert the green clay into the extruder, and extrude a thin cylinder of clay for the stems. Cut out tiny individual flower petals and leaves with the PAC-PEN or cutters in green and white. Roll tiny yellow balls for the flower centers.

Put Everything Together

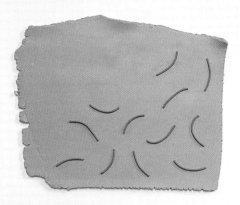

Cut stems to the desired length from the extruded green clay. Space them out on the blue base slab, making sure to leave enough space between each stem for flowers and leaves.

Place petals at the top of the stems to form flowers. You can make each flower the same for a uniform look or move the petals around to create unique flowers of different sizes and shapes. Remember that you need only light pressure to attach these pieces to the base slab.

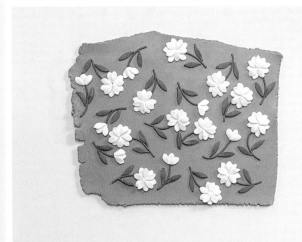

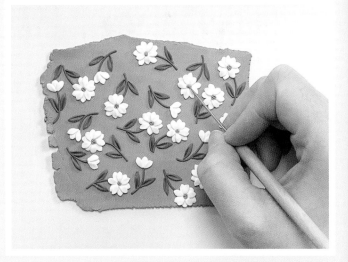

Attach the leaves. Place 2 leaves on each stem for a uniform look, or mix it up for each flower. Try to fill the space so there aren't large gaps between any of the flowers.

Poke the center of each flower with the ball stylus, and place a yellow center in each dent. Then gently use the needle tool to texture the leaves and flowers. Make small divots in each yellow center. Draw subtle lines in the petals and leaves to show depth.

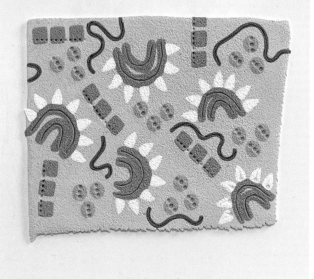

ABSTRACT SLAB

In an abstract design, a lot of colors and shapes are mixed in a creative, interesting way. I love that every shape I cut out of an abstract slab is its own one-of-a-kind piece of art. This design will work as either a flat or a three-dimensional slab, or you can use a mix of both.

It can be really helpful to have a couple inspiring pictures to reference. This doesn't have to be a polymer clay photo—anything can inspire you! The key to an abstract design is the color palette. I suggest choosing at least four colors for the slab. If you're feeling stuck, use Pinterest or a color palette–generating website for ideas.

MATERIALS

4–5 colors of polymer clay

Pasta machine **or** depth guides and a roller

Craft knife

Small cutters

PAC-PEN

60-grit sandpaper for texture (optional)

Roll out the base color to 2mm depth using a pasta machine or depth guides and a roller. Cut out and extrude different abstract and geometric shapes with the remaining colors.

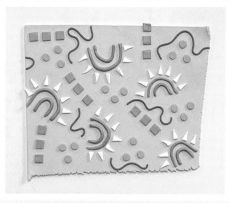

Layer the pieces onto the base slab. You can place them randomly or build a pattern.

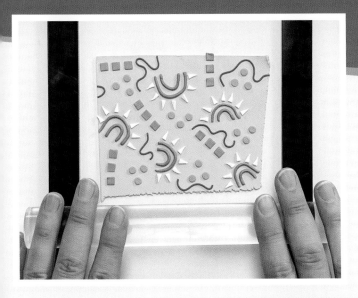

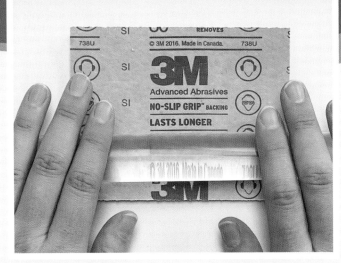

Use the depth guides and roller to roll down the layered pieces into the base slab.

To give the slab some extra texture, lay sandpaper facedown on the slab, and roll it firmly onto the clay. Remove the sandpaper by gently peeling it up. Then, using any other tools or objects, add extra texture, like polka dots, lines, or grooves.

PRO TIP If you are adding texture to your slab with a needle tool or other objects, start by testing out your design in the corner of the slab. You just worked really hard on your slab, and there's no turning back once you start adding texture!

Using Slabs

Now that you've made a slab, what do you do with it? Anything! You can use the whole slab for a bigger project like a wall hanging or an incense holder. You can cut it up for smaller projects like jewelry, barrettes, or candle holders.

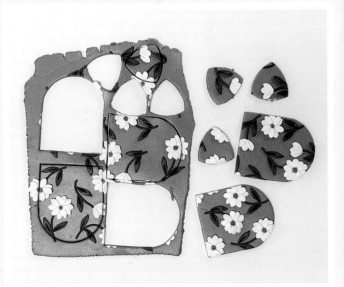

You worked really hard on the slab, so if you're going to cut it up into smaller pieces, make sure you're using every square inch of it by getting the cutter as close to the edge and the other pieces as possible. Each piece is going to look a little different, so look closely at every piece you cut out to make sure you like the way the pattern looks individually. Pick a cutter big enough to showcase different aspects of the pattern.

For a matched pair, you won't get identical pieces, but try to cut pieces with the same colors and about the same amount of pattern on each piece so one doesn't look busier than the other.

Color Mixing

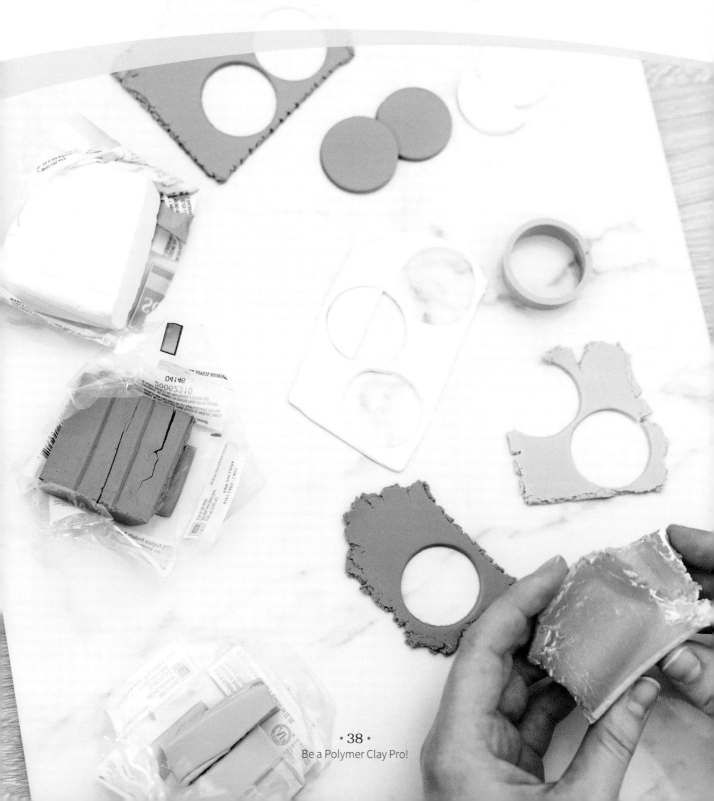

Be a Polymer Clay Pro!

Polymer clay already comes in a huge range of colors, so there's no need to mix anything if you don't want to! But it's nice to be able to create any custom color. You can figure out color recipes for yourself or purchase the recipes from other artists. When looking for color recipes from others, pay attention to which brands of clay they use. The varying color saturations in different brands of clay can make a big difference in the final look of the color.

Where to Start

Start by grabbing a color you like and making a small adjustment to it. Add white or black to it, and see what range of shades you get. This is an easy way to get used to mixing two colors together. Knead and twist the two colors together until you no longer see any marbling.

I don't always want to take time or possibly waste clay figuring out a particular color recipe, so I have purchased several recipes that I love. You can find recipes on Pinterest (that's where I've found the most free recipes), Etsy, or Instagram from various small businesses. Recipes list each amount of clay you need as a "part." This is so you can measure amounts of each original color in relation to each other. Grab any size cutter (I like to use a circle), and cut out a piece of clay. This is one "part." If the recipe calls for ½ a part, just cut the circle in half. The size of the cutter doesn't matter as long as you use the same cutter for the whole recipe. Choose the size of the cutter based on the amount of the color you need.

PRO TIP Whether you are purchasing a recipe or coming up with one yourself, start with a small amount of clay! I can't tell you how many times I've started a recipe, messed it up, and ended up with a big pile of a color I didn't want. Even if you purchased an exact recipe, if you've never made that color before, use your smallest circle cutter, and make only a small amount to start. Your color might look different from the one pictured.

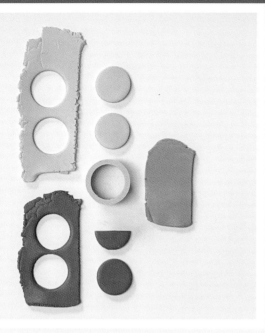

DUSTY ROSE COLOR RECIPE

MATERIALS	RECIPE
Sculpey Soufflé Cinnamon	1½ parts Cinnamon clay
Fimo Sahara	2 parts Sahara clay

Mix the two parts by kneading, twisting, and pressing them together until they have fully combined and there is no more marbling of the two colors.

Experiment by adding more or less Sahara to adjust the darkness of the dusty rose color.

PRO TIP When purchasing a recipe, look for a listing that has a picture of the color in actual clay. Many will have only digital renderings of the colors, and I can promise you that they will most likely look different in clay form.

Adding Color with Alcohol Ink

Alcohol ink is another common way to add a little color to translucent clay bodies. You need only a few drops to add a punch of color. One important thing to remember: There is a huge color shift after baking because translucent clay becomes translucent only after baking.

After you mix in the ink, pinch off a small piece, and pop it into the oven. Add more ink to the clay if you're not happy with the baked color. This coloring method is a great way to make faux sea glass!

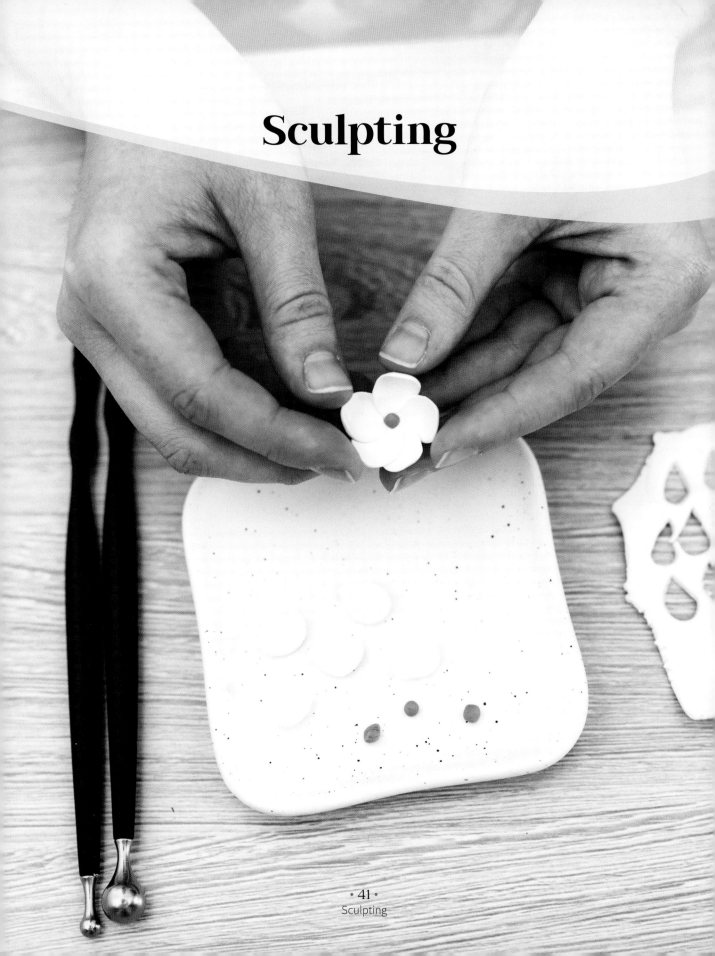

Sculpting

Polymer clay is a great DIY material for home decor. From small sculptures to wall hangings to ornaments, you can use polymer clay to add a little something special to your home.

Sculpting Bigger Pieces

We will be talking about and making only small sculptures in this book, but there are many artists who make incredible large-scale sculptures with polymer clay! When making anything larger than a few inches, start with some kind of armature. Use wadded-up tin foil and wire to create the basic shape of your project, and then cover it with clay. This will help add sturdiness to the piece, save you from using too much clay, and help keep the piece as light as possible.

I highly recommend creating and baking in layers. The more you work on and handle clay, the warmer and softer it gets. You don't want to spend time and effort on something that will easily get smooshed. Create an armature, cover it with a thin layer of clay, prop it up in the oven in the exact position you want, and bake it. Now you have a sturdy upright base to work on!

BEADS

You can easily string beads you've bought onto a project, but it's very fun to make your own beads from clay. This is easiest to do with a bead roller. It's a two-part tool; to roll out a bead, place clay inside, and slide the two pieces back and forth. You can find bead rollers in many shapes and sizes on Etsy. If you don't have a roller, you can make beads by hand. Roll the clay into the shapes you want, and then use a needle tool to punch holes through the middles.

PRO TIP Drop beads into ice water before you poke holes through them; it will keep the clay stiff enough to handle without distorting the shape of the beads.

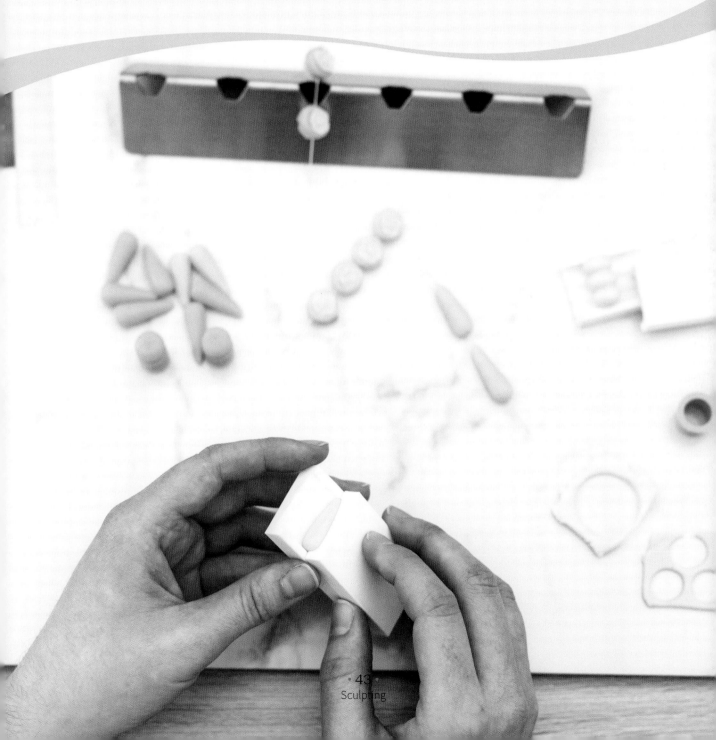

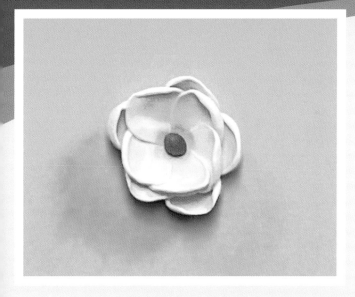

FLOWERS

Flowers are great sculptures both as stand-alone designs and as additions to a project! There are tons of fondant cutters and tools for making flowers, or you can make petals from molds, from polymer cutters, or by hand. My PAC-PEN is my best friend when I create flowers. I like to use the pen to cut out the petals and then use my hands to manipulate them into their final shapes.

MATERIALS

PAC-PEN with petal tip

White polymer clay

Yellow polymer clay

Large ball stylus

Medium ball stylus

Needle tool

Roller and depth guides **or** pasta machine

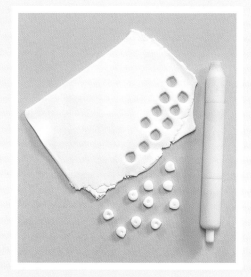

Roll out a base slab of white clay to 2mm depth using the roller and depth guides or pasta machine. Cut 10 large teardrop shapes using a PAC-PEN or cutters.

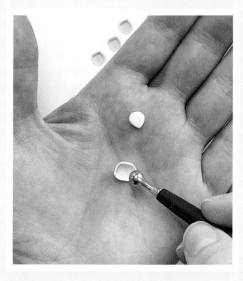

Place one petal in your palm. Press the petal out with a ball stylus until it's a little bigger and thinner. Don't distort the shape too much; you still want it to look like a teardrop. Repeat with all 10 petals.

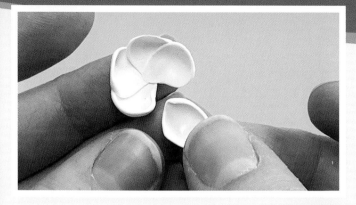

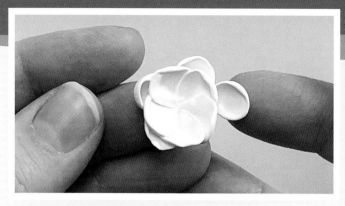

Join 5 petals into a circle with the fattest part of the teardrops toward the outside. The petals should slightly overlap. They will stick together with light pressure.

Place the 5 remaining petals behind the circle of petals, letting them peek out between and beneath the top petals.

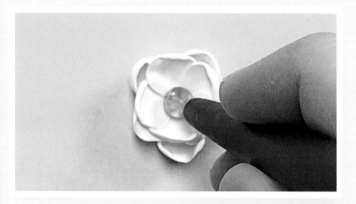

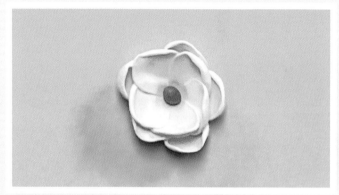

Set the flower on the work surface, and press down in the middle of the flower with the medium ball stylus.

Fill the middle of the flower with a pinch of yellow clay.

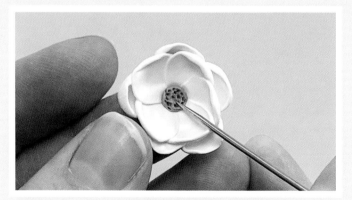

Finish the flower by adding a dotted texture to the yellow center with the needle tool.

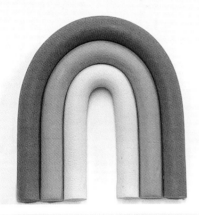

RAINBOWS

Sculpted rainbows can be any size. A rainbow can be the entire design, or you can attach it to a bigger project. Change up the size by changing the thickness of the ropes you extrude.

MATERIALS

3 colors of polymer clay

Extruder

Thin pill-shaped cutter

Blade

Condition the clay. Then use a circle disk to extrude long ropes of clay in various colors. I am extruding at ½″ (1.2cm).

Press 1 of the ropes around the cutter in a U shape. If you don't have this cutter, find something else with a round shape, or freehand it.

Layer the other 2 ropes around the first one. Add as many ropes as you want until you're happy with the size.

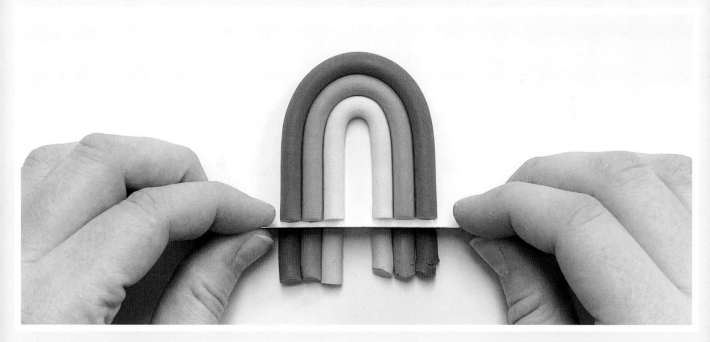

Gently remove the cutter from the middle. Trim the bottom of the rainbow with the blade so the ropes are all even.

Imprinting

Be a Polymer Clay Pro!

There are tons of tools you can use to imprint clay: Rubber texture mats, stencils, clay/pastry texture rollers, and stamps are all great options for polymer clay. And don't forget that anything you find around your home will work too! In this chapter, we'll explore how to use a few texture tools.

Texture Mats

Roll out a slab of clay using a roller or pasta machine. Place a texture mat facedown on top of the clay, and press it into the clay so it won't move around. I am using a scalloped texture tile that I purchased online from Cool Tools.

Firmly roll the mat into the clay using a roller. Roll over it only once so you don't get a double imprint.

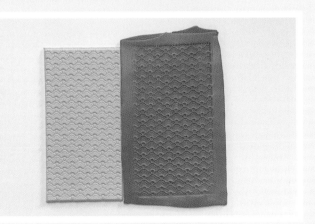

Gently remove the mat to reveal the textured pattern.

Stencils

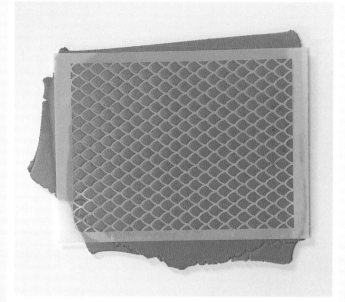

Roll out a slab of clay using a roller or pasta machine. Lay a stencil flat on top of the clay. Firmly roll the stencil into the clay using a roller.

Remove the stencil to reveal the textured pattern.

Textured Rollers

You can find textured rollers made just for polymer clay, and you can find ones made for pastry, pottery, and fondant. I am using a roller from MKM Pottery Tools.

Roll out a slab of clay using a roller or pasta machine. Roll the textured roller across the clay with firm pressure.

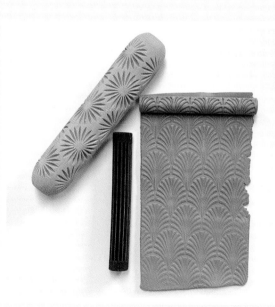

PRO TIP A stencil is the easiest texture tool to use, but it won't give you as deep an imprint as a texture mat or roller.

Molds

Molds come in any shape and any size. Silicone molds and molds with shallower depths work best with polymer clay, but clay molds, resin molds, fondant molds, and chocolate molds are all options. Molds can save you a ton of time. Don't feel like sculpting a million bows in a row? Grab a bow mold, and just keep refilling it! Molds also will allow your elements to achieve a uniform look, and you can add tiny details that would otherwise not be worth sculpting by hand.

FLOWER MOLD

You can find flower molds in all kinds of shapes and sizes. They're great as stand-alone designs. Instead of hand sculpting flowers for a slab, you can use a tiny flower mold to save time and ensure consistency.

MATERIALS

Flower mold

Clay

Blade

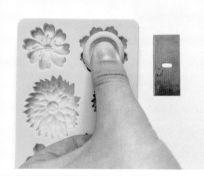

Firmly press clay into the mold until it's filled.

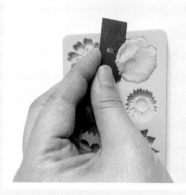

Carefully cut across the top with a blade to remove extra clay.

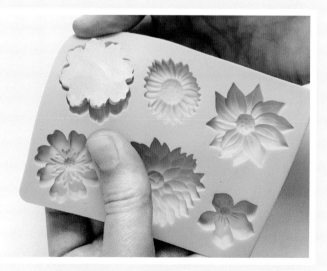

Gently remove the flower from the mold by bending and loosening the sides of the mold.

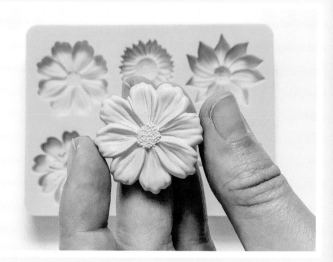

Once you have the flower out, it's ready for a project!

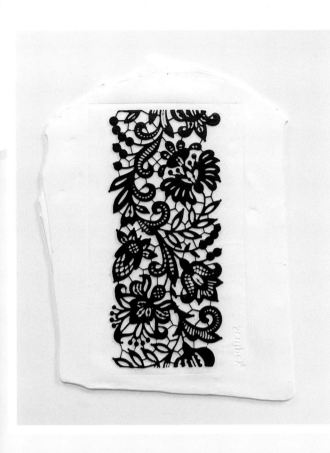

LACE MOLD

To achieve a lace pattern with two colors of clay, we're going to use a lace mold. This is a technique that takes patience and practice. Your first go at it might feel sloppy and frustrating, but I promise after a few tries you'll get it! Lace is one of the trickiest patterns.

MATERIALS

Lace mold

2 colors of polymer clay

Blade (I prefer a small box cutter)

Roller

Press a small piece of the lace color into the corner of the mold. Slice the excess clay off the top of the mold using the blade so the clay is flush with the mold. If it feels like you're cutting the mold while you're slicing the excess, play around with the blade angle until you find one that works for you.

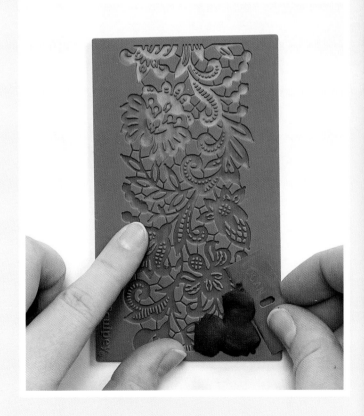

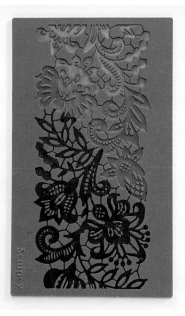

Continue filling the rest of the mold, pressing clay into a new spot and slicing the excess away. If you find yourself with a few bald spots, just refill and slice again.

Roll out a slab of the base color bigger than the size of the mold. Flip the filled mold over on top of the slab. Using the roller, firmly press the mold into the clay base.

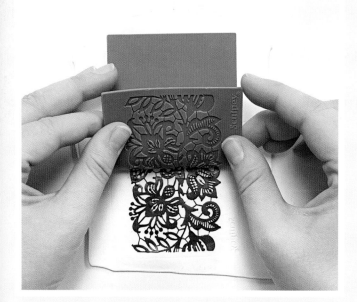

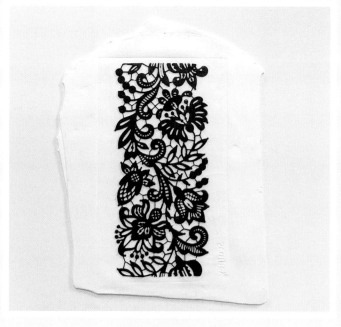

Start at one end, and carefully begin lifting the mold off the clay. Go slowly, and press the mold back down if pieces of the lace get stuck in the mold instead of adhering to the clay.

The lace slab is now ready to use for a project!

PRO TIP Using a stiffer clay, like Cernit or Fimo, will make filling the mold slightly easier.

Using Scraps

Don't get rid of your scraps! Don't throw away the materials you've invested in! Polymer clay is plastic, so we want to reduce the amount of waste as much as possible. Save all of the little bits and pieces that are left over after you complete a project.

SMOOSH SLAB

This is exactly what it sounds like! It's a really fun way to use up scraps and create a colorful, one-of-a-kind slab.

MATERIALS

Scrap polymer clay

Blade

Pasta machine **or** roller

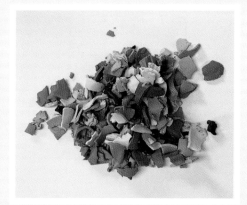

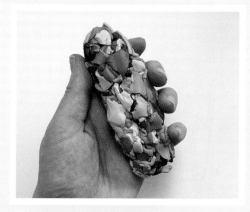

Choose colors of scrap clay that you think go well together. Avoid using black for this technique as it will make all of the rest of the colors look muddy. Condition all of the scrap colors separately. Then, tear them up into little pieces, and mix them into a big pile.

Use your hands to squish and smoosh the pieces into a log. Squeeze and roll it tightly to avoid air pockets until the log is smooth on the outside.

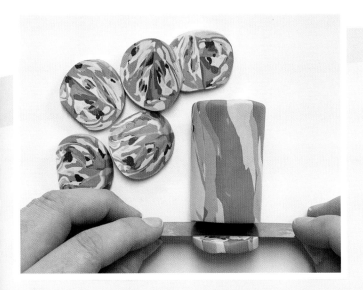

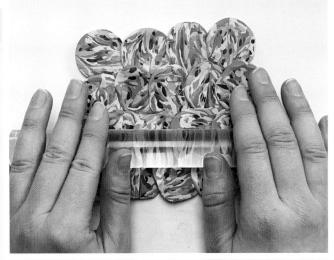

Slice the log up with a blade. Slices should be 3–4mm thick but don't need to be perfect.

Lay the slices down with the edges slightly overlapping and no gaps between pieces. Start rolling. I like to start with a roller and then run it through the pasta machine.

Roll until smooth. Use depth guides if you want to achieve a certain thickness. Now you can leave it as is and start in on a project, or you can add some texture. Good thing you didn't toss those scraps!

Mixing New Colors

Another great way to use your scraps is to mix them up into new colors. Have five piles of various shades of red? Mix them together and get one new shade. Add the tiny scrap of green to the new block of green you just opened. You won't always be able to recreate the colors you mix from scraps, but you'll create less waste and make your pieces unique!

Unique Ideas to Use Every Last Bit

Sometimes you'll mix up a bunch of scraps, and it'll just be a pile of ugly. Or there might be too much gunk and dust in a pile for you to use it in a project. You can still use the clay!

Use the ugly, dust-filled clay to test out new designs. Not sure how you want to drill holes in a piece? Practice on scraps. Wad up some of the clay, and use it to prop up or hold something in place while baking. Use it in the center of a sculpture. Practice your resin skills on scraps. Take every opportunity to use up your scraps and learn in the process!

Making Canes

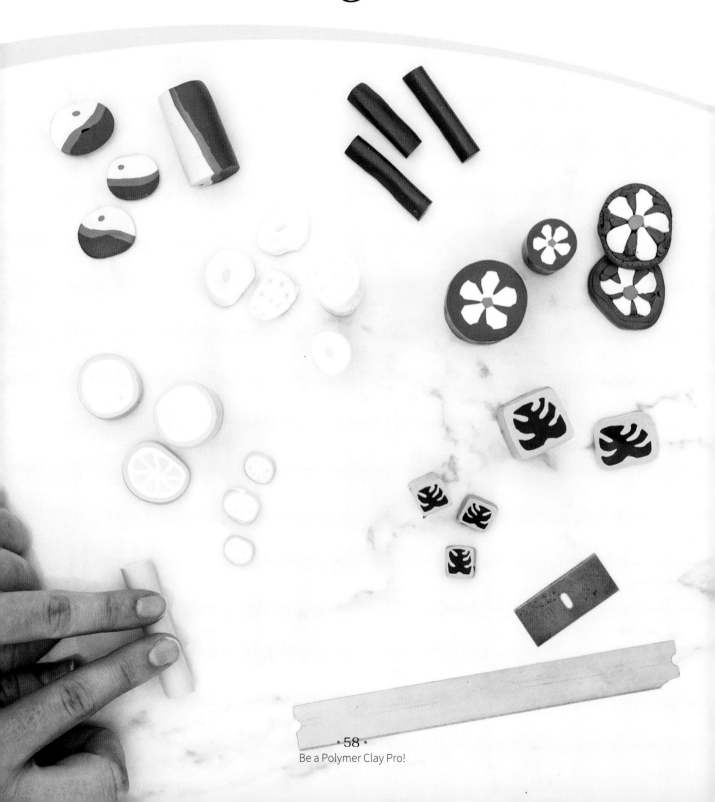

Cane work is both very simple and very complex! A beginner can create beautiful patterns with little to no instruction, but it's also possible to create intricate kaleidoscope-like canes that take an incredible amount of skill and practice to achieve. I'm going to introduce you to some basics of cane making to get you started.

Making a cane reduces the size of your planned pattern. So you need to start bigger than you think. If you start too small, your pattern will disappear. Cane work will look very messy in the beginning; it requires a lot of trust in the process. It will start to look cleaner the more you work on it.

Using stiffer clay, such as Fimo or Cernit, will help keep your pattern clean and crisp. But don't use stiff clay and soft clay in the same cane, or your cane will end up lopsided.

LEAF MOTIF CANE

MATERIALS

Dark green and light green polymer clay

Blade

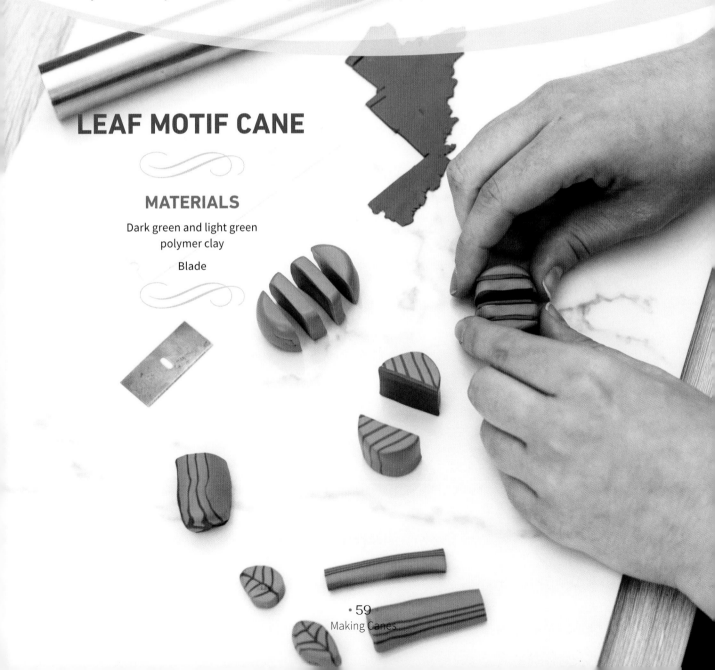

Forming Your First Cane

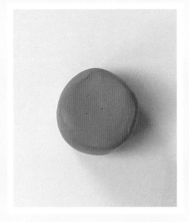

Roll the light green clay into a circle that is 1″ (2.5cm) thick and 1″ (2.5cm) wide.

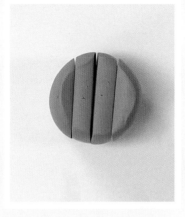

Slice into the circle three times. This should split the circle into four even slices with three gaps.

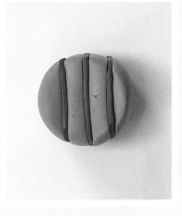

Roll out the dark green clay into a thin sheet. Insert the dark green clay between the light green slices, and join the pieces back together.

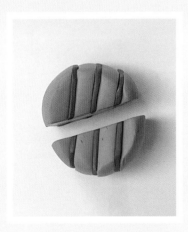

Slice the circle in half at an angle across the stripes.

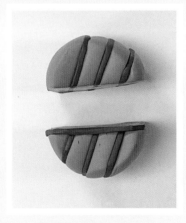

Form another strip of dark green, and attach it to the center of one half.

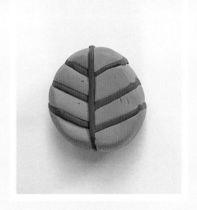

Flip over one half of the circle. Join both halves together so the dark lines on each side form a V shape.

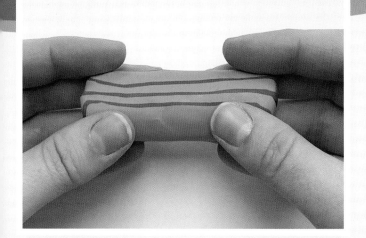

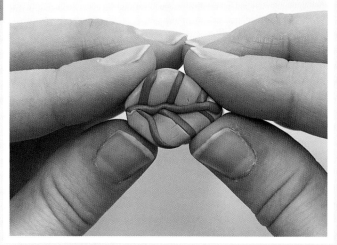

Turn the leaf shape to the side, and starting in the center, begin slowly squeezing and pulling the cane smaller and longer. Stretch the shape until it is an oval-shaped cylinder that is about 2″ (5.1cm) long.

As you pull and squeeze, begin shaping the cane into a teardrop leaf shape. Look at the end of the cane to fit the shape to the leaf design.

Some size options for the cane

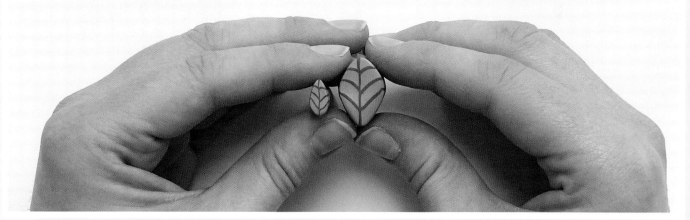

When you're happy with the size of the leaf, slice off the end of the cane, and check out the pattern! It's now ready to be cut into slices and used for a project!

PRO TIP Before you slice up a cane, pop it into the refrigerator for 20–30 minutes to stop it from getting squished when you cut it.

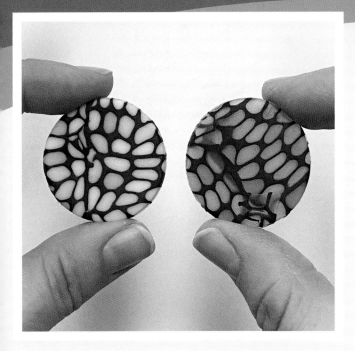

STAINED GLASS

MATERIALS

4–6 colors of translucent polymer clay

Black polymer clay

White translucent polymer clay

Blade

Roller

Forming the Stained Glass Cane

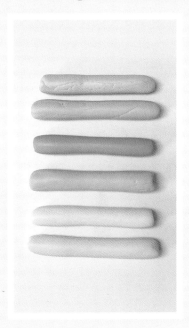

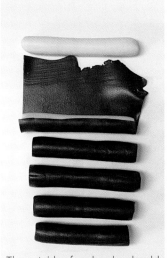

The outside of each color should be covered with black clay.

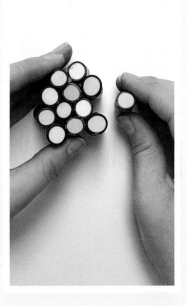

Roll out each of the translucent colors into a long rope.

Roll out the black clay very thin. Cut it into slices, and wrap it around each of the colored ropes.

Slice each tube in half, and stand up all of them on their ends. Join them all together by pressing the sides of each cylinder to touch. They should form a wonky circle when you look down from above.

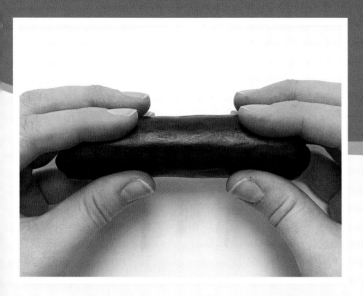

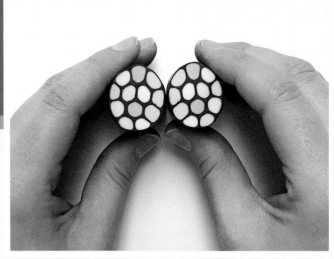

Turn the cane to the side, and starting from the center, slowly squeeze, roll, and pull the cane until it's twice as long. You should no longer be able to see the separate cylinders from the side, and the top should be circular.

Slice the cane in half. Then stand each cylinder up on one end, and join the two halves back together again by pressing the sides of each to touch.

Form the Stained Glass Slab

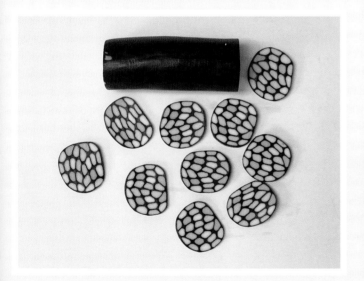

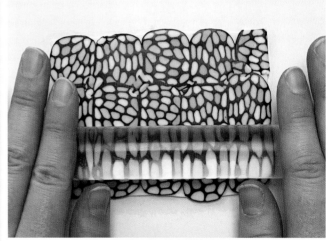

Squeeze them together until they're firmly attached. Roll the two cylinders back into one. Shape the cane into an oval. Then slice the stained glass cane in 2mm- to 3mm-thick slices.

Roll a very thin slab of white translucent clay. Lay the slices out side by side on top of the slab. Roll the slices down evenly.

Cut shapes out of the slab to fit your project. Once it's baked, the clay will become translucent and look like stained glass!

Creating Patterns

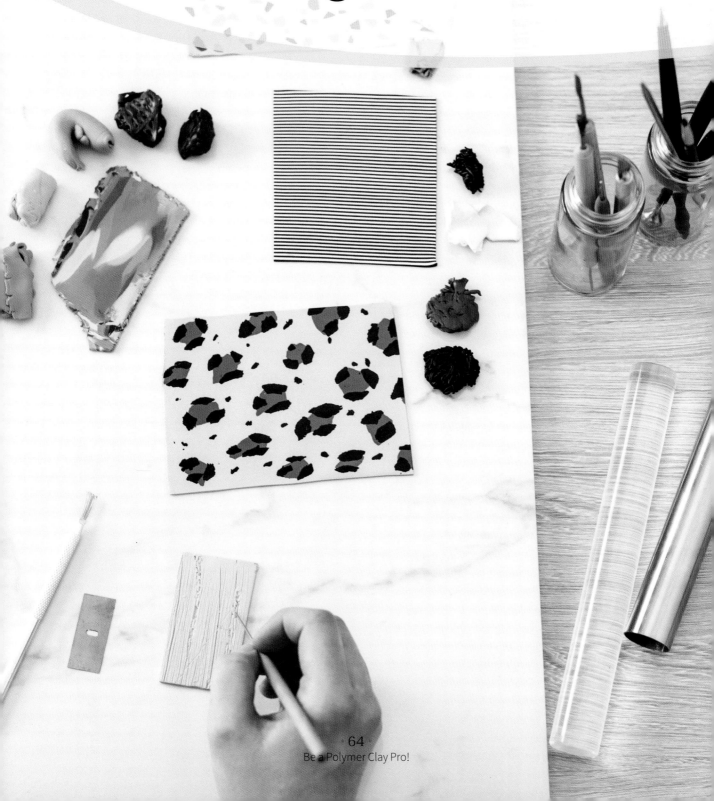

Be a Polymer Clay Pro!

With polymer clay, there are an endless number of patterns you can make and endless ways to create them. I could fill a whole new book with ten ways to make each pattern! Instead, I'm just going to share some of my favorite ways to make these patterns.

STRIPES

MATERIALS

Black and white polymer clay
(or any two colors!)

Extruder

Roller

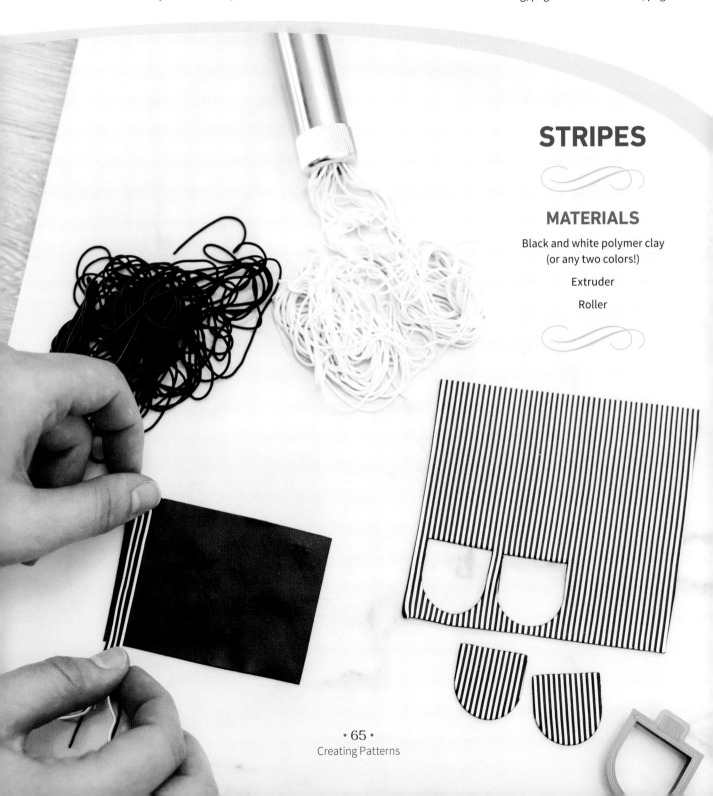

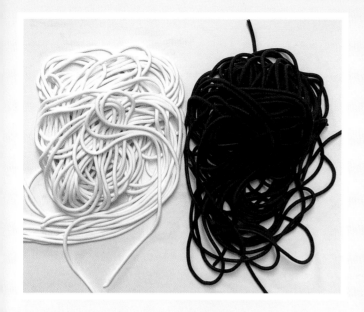

Extrude a small pile of each clay color using an extra-small circle disk. The more ropes you extrude, the larger the striped slab will be.

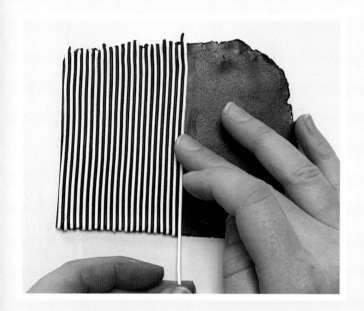

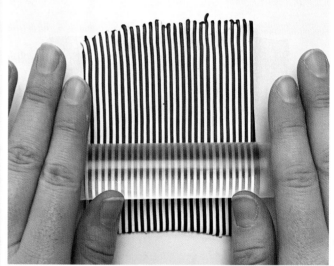

Roll out a thin slab of black clay for the base. Begin laying down the extruded strings, alternating between the two colors. Make sure the strings are tight and close together.

Use a roller to lightly roll the slab in the direction of the stripes. You want to move slowly and smoothly so the stripes don't get distorted. Roll it until the lines are even and merge completely with the base slab.

PRO TIP To merge and smooth a patterned slab a little faster, run it through a pasta machine. Set the width to just the smallest bit thinner than the slab of clay (if it's set way thinner than the slab, the pattern will get distorted). Run it through the machine in the direction of the pattern if it's directional, keeping it as straight as possible.

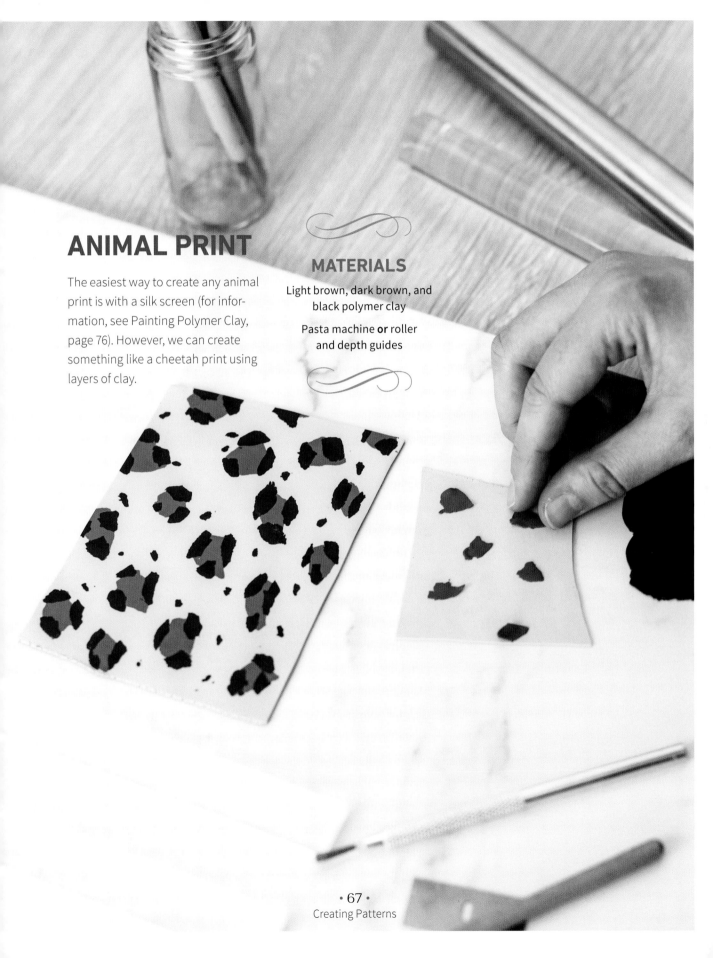

ANIMAL PRINT

The easiest way to create any animal print is with a silk screen (for information, see Painting Polymer Clay, page 76). However, we can create something like a cheetah print using layers of clay.

MATERIALS

Light brown, dark brown, and black polymer clay

Pasta machine **or** roller and depth guides

Roll out a light brown slab to 2mm depth for the base. Then roll out extra-thin slabs of the black and dark brown clay.

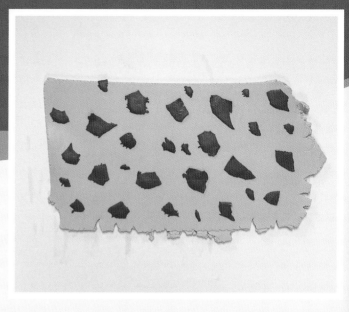

Tear pieces of dark brown clay into various abstract shapes and sizes. Space them out on the base slab.

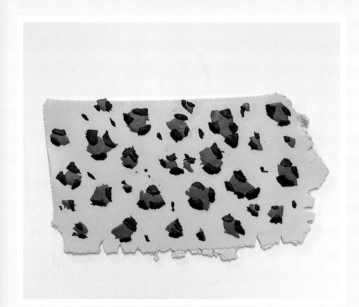

Tear off smaller pieces of the black clay. Then place 2–3 pieces of black overlapping each dark brown spot.

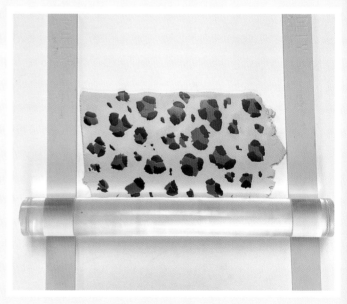

Roll the slab flat with a roller and depth guides for a smooth animal print pattern.

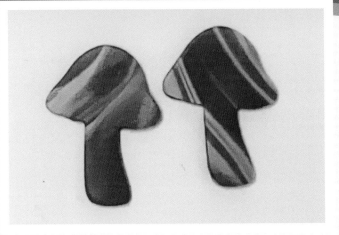

MARBLING

Marbling is just a swirl of colors, and you can do it with as many colors as you want. The key to a good marble is knowing when to stop! Run it through the pasta machine one too many times, and it'll turn into a solid color.

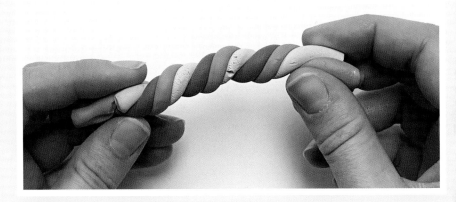

Roll all of the colors into different sized ropes, and then start twisting and rolling them together.

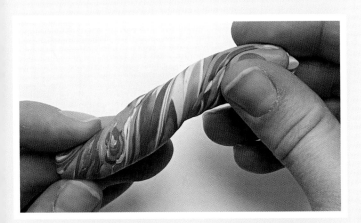

Fold the twist in half, and continue twisting it until the colors swirl.

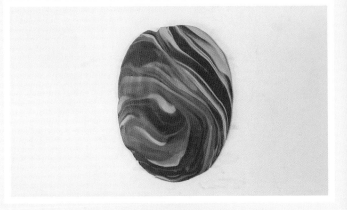

Roll out the clay with a roller or pasta machine. If the slab is marbled enough for you, you're done. If not, fold it in half, and roll it out again. Be careful that you don't mix it too much!

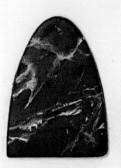
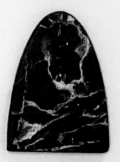

STONE: BLACK GRANITE

Use any color combination to create any kind of stone! Get inspiration from nature, and go wild! In this project, we're making black granite.

MATERIALS

Black polymer clay

White acrylic paint

Blade

Roller **or** pasta machine

Gloves

Use a blade to chop the clay into different-sized chunks.

Add a small dollop of white paint to the clay, and mix together. Use gloves when mixing to avoid getting paint all over your hands.

Let the paint dry on the chunks of clay before pressing everything together tightly into a square log with your hands.

Be a Polymer Clay Pro!

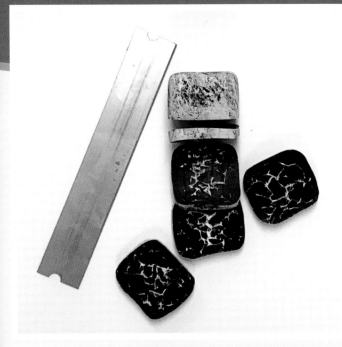

Slice the log into thick chunks, and lay the pieces down with the edges slightly overlapping.

Run the slab through a pasta machine, or use a roller to roll it out. Now it's ready for a project!

After you cut out a shape and bake it, you can lightly sand away any paint that might have smeared.

WOOD

One of my favorite things is when someone asks me what type of wood I use, and the answer is, "It's actually all clay!" This technique will give you a weathered wood effect.

MATERIALS

Fimo Sahara polymer clay

Needle tool

Comb tool

Toothbrush

Dark brown acrylic paint

Roller **or** pasta machine

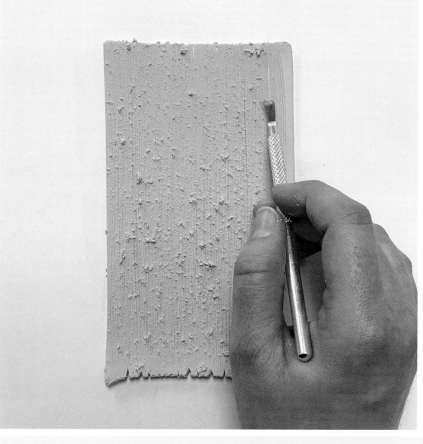

Roll out a slab of the Sahara clay, and use the comb tool to completely cover the clay with lines, all going in the same direction.

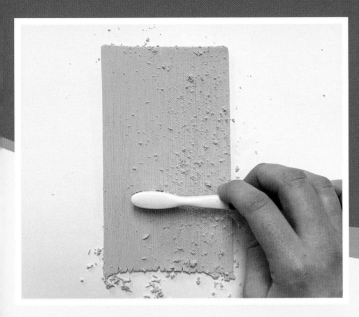

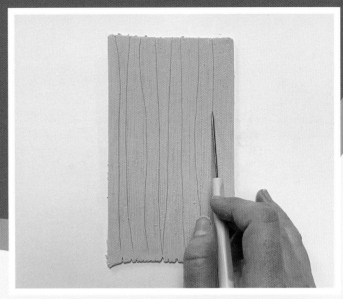

Use a toothbrush to gently brush off the little pills of clay the comb caused. If the toothbrush smooths out too many lines, just go over them with the comb again.

Using the needle tool, run long, irregular lines across the clay so that each "panel" of wood looks different. Make sure you don't press the needle tool too deeply into the clay. If you push too hard, the lines will become too deep, and they will be a point of weakness in the project.

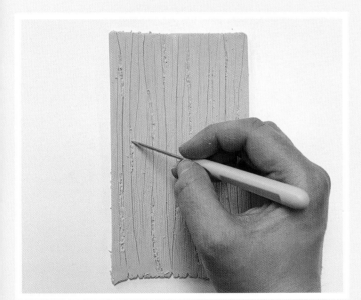

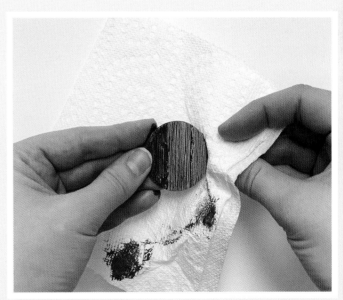

Use the needle tool to pick at the clay along some of the lines to give it a more weathered appearance.

Cut the clay to the shape needed for your project, and then bake. Let it cool, then coat it with dark brown paint. While it's still wet, wipe the paint off with a paper towel.

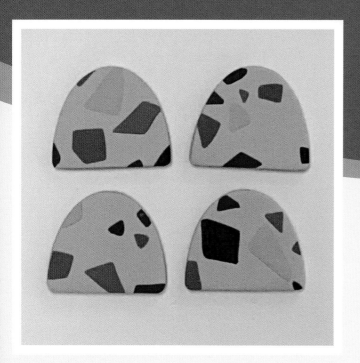

TERRAZZO

Terrazzo is a mosaic composed of chips of broken stone. It is a beautifully simple thing to re-create in clay, and it can be made in any color combination you like!

MATERIALS

2–4 colors of polymer clay

Blade

Roller

Depth guides **or** pasta machine

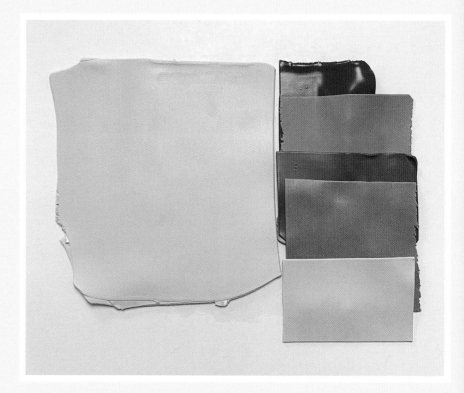

Roll out the base color to 2.5mm depth. Roll out the remaining colors as thin as possible.

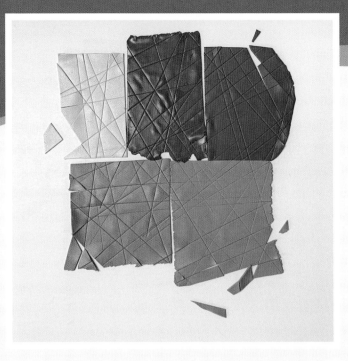

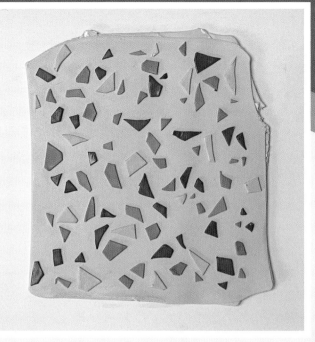

Chop the thinly rolled colors into random geometric shapes in a variety of sizes with the blade. They should not look perfect or regular in size or shape!

Spread the pieces out in a random pattern on the base slab. You want the pieces to be very close together.

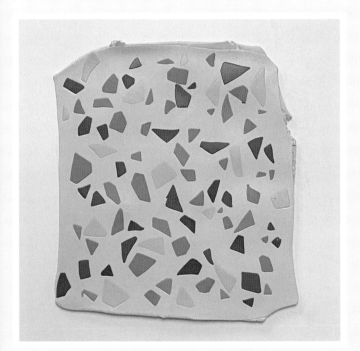

After you lay down all your colors, use depth guides and a roller or pasta machine to roll the slab flat to 2–3mm.

PRO TIP You can use the tearing method we used in the animal print technique for terrazzo. It's much faster and less tedious but will have a more irregular, relaxed look.

Painting Polymer Clay

Painting on polymer clay opens up a whole new world of possibilities! Polymer makes a wonderful base for a variety of painting mediums.

Alcohol Ink Pens or Markers

All brands of alcohol ink pens will work, but my personal favorite is Prismacolor. After you roll out clay, draw whatever you like with the pen! I find that these pens work best on raw clay. Use a light hand when drawing to keep from denting the clay with the tip of the pen. Also, the pen will stop working if it gets clogged with clay, so be gentle. When you first make a drawing, the colors will look gorgeous and vibrant, but be aware that the colors will fade significantly in the oven. So I like to lightly line my design with a black pen to give it a little more definition.

PRO TIP Alcohol ink will start to leak and spread on raw clay after a couple hours. So make sure to bake the pieces immediately after using an alcohol ink pen. Once the ink is baked it is set, and there's no need to seal it.

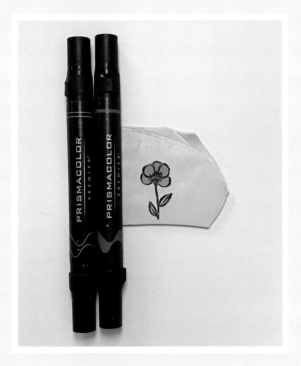

Alcohol Ink

Just like alcohol ink pens, alcohol ink is best used on raw clay. I don't have a particular brand I prefer; I choose my ink based on which color I want. You can use a paintbrush to spread the ink on your surface, or grab a straw and blow on the ink to spread it. You can use a heat gun or blow dryer to move the ink around, but be very careful with the heat. You don't want to partially cure the clay at this stage.

Let the ink fully dry before baking, but don't let it sit much longer than that. Unlike when using the pens, I highly recommend you seal the pieces after baking. Because you're using so much more ink, the ink can rub off or lift from the clay surface. My preferred method of sealing ink is resin; the shine of the resin really makes the ink pop (for more information, see Resin, page 26).

Alcohol ink can be used to color translucent clay by mixing it into the clay. When you mix the ink into the clay, you don't need to worry about baking it right away.

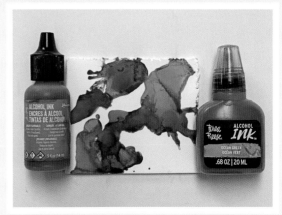

Paint Pens

If you're not confident in your ability to paint with a paintbrush, you can try paint pens! Use them on baked clay instead of raw clay so the tips of the pens don't dent the clay and the clay doesn't clog the pens. I've always used POSCA pens, but any brand that has acrylic paint pens will work. There's no secret trick to using them; just draw on the clay like you would on paper. Any time I use a paint pen, I put my pieces back in the oven for 20–30 minutes to heat set the paint. I like to seal over paint applied with paint pens using varnish or resin for the look, but it's not required.

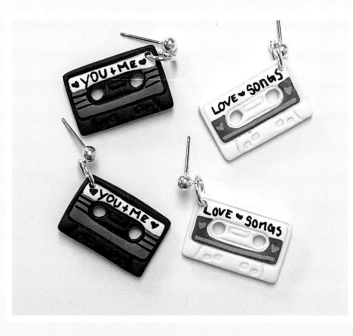

PRO TIP When you first use a paint pen, you have to press down on the tip to get the paint flowing. Do this on a separate surface, not the project! You may have to repeat this if you pick up the pen after a long break.

Acrylic Paint

Acrylic paint is a water-based paint that is very compatible with polymer clay. There's no trick to using paint on polymer. Paint clay just like you would any other surface. You can use it before or after baking. It can be baked in the oven safely (as long as you're using the correct temperature). If you paint after baking, after the paint dries, pop your project back in the oven for 20–30 minutes to heat set the paint.

In addition, unless you feel like the design will be scratched or rubbed off, you don't *have* to seal the piece after you paint it. I often will because I'm going for a particular finish, but there are plenty of times and reasons to leave it as is. When using paint on raw clay, let the paint dry before you continue working with the clay so you don't accidentally smudge the design.

Silk Screens

You can use a silk screen to print a pattern on clay just like you would screen-print a design on a T-shirt. There are small silk screens made specifically for polymer clay. You can use silk screens made for cookie decorating too, but I prefer using the ones for clay.

A silk screen is an easy, fun, and fast option for a design that isn't worth making with other methods. A great example of this is a buffalo plaid pattern. I can create it by making a plaid cane; however, it's a lot of work, and my lines are never as precise as I want them to be. I also can create it by manually cutting out different colored squares and assembling them into a plaid pattern. But that's so incredibly time-consuming and again not as precise as I would like. So I would rather use a silk screen. I get exactly the look I want in a fraction of the time.

SILK SCREEN PATTERNED SLAB

MATERIALS

Silk screen

Acrylic paint

1 color polymer clay

Old credit card or thin, stiff piece of plastic

Pasta machine **or** roller and depth guides

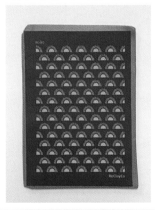

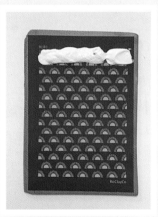

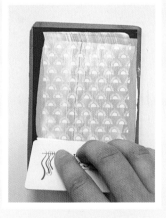

Roll out the clay base as a 2mm slab. Place the silk screen on the clay with the shiny side down.

Squeeze a small amount of acrylic paint onto the top edge of the screen. You'll need less paint than you think.

Spread the paint across the screen using the card/plastic. Scrape to remove any excess paint.

Peel off the silk screen, and immediately wash it in lukewarm water. Never let paint dry on a silk screen; it will ruin it! Let the paint dry on the clay for a few minutes to avoid smearing. Now it's ready to be cut up and used in a project!

Adding Extra Elements

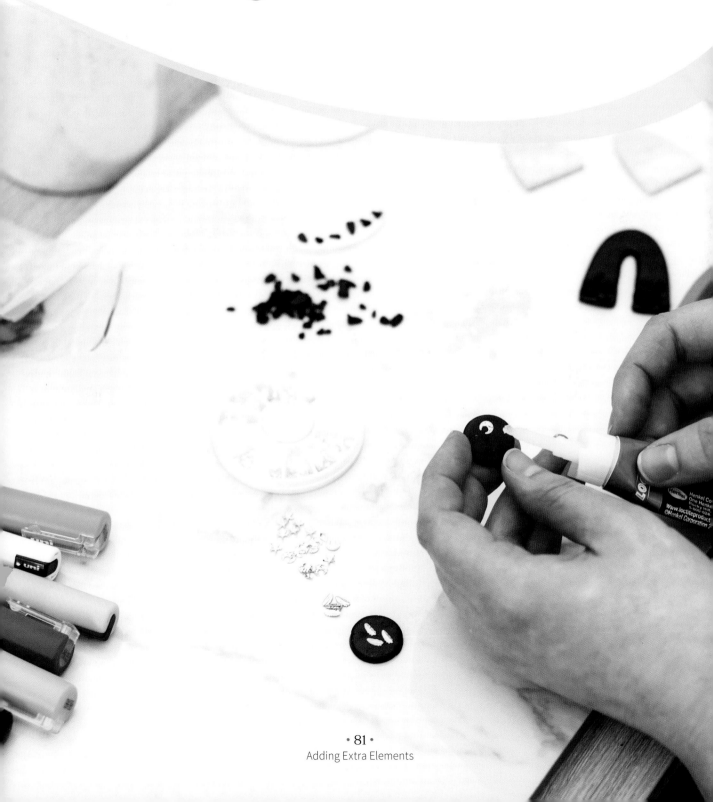

There are so many things you can incorporate into clay! I'm never done experimenting. As long as it's safe to bake in the oven or can be glued on later, it's fair game—including mirrors, sand, stones, metal, and so many other things! You should always consider how the clay will react to whatever you are adding and whether it will stick to your clay in the long term. Finally, how you attach things to baked clay is very important.

Making Sure They Stick

LIQUID CLAY

Liquid clay can be added between raw clay pieces that need extra help sticking, and it is very easy to use. Liquid clay also can be used as a glue to bake something into a piece. If I'm adding something like sand, I mix liquid clay and sand and then bake.

If you have two pieces of baked clay you want to join or a crack you want to repair, you can glue the edges together with liquid clay and rebake.

EMBEDDING

Embedding elements means slightly overlapping two pieces to hold them in place. This works great for adding something like a mirror, a rock, or a stone. As long as you overlap the edge enough for the clay to lock it in place, embedded add-ons will stick tight.

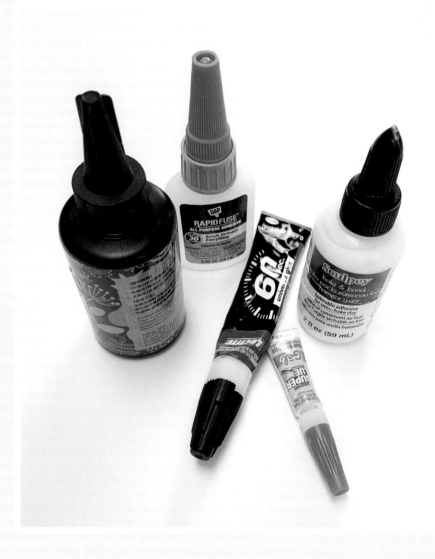

GLUE

Most glues don't work for polymer clay. Gel Super Glue is best. My two favorite glues to use are Loctite 60 Second Universal Glue and Zap Jewelry Gel. There *are* other brands that carry gel Super Glue; Gorilla is a popular one.

Generally speaking, you need to use only a little bit of glue when attaching something. You don't want a bunch of glue squeezing out on the sides of the project. Polymer clay can sometimes react to too much glue by *frosting*, meaning leaving a white residue. No need to panic if this happens; it can be rubbed off with a cloth, or you can give it a light scrub with a spoolie or stiff brush.

I prepare my pieces before gluing. Lightly slice up both clay surfaces in a crosshatch pattern with a craft knife where they will be attached. Wipe both surfaces with a little rubbing alcohol. Once they both dry, glue the pieces together. Roughing up both surfaces will give the glue a little something extra to grip onto and give your piece more longevity.

Attaching Findings

Findings are often easily attached with glue after a piece is baked. But there are three other methods of attaching findings, specifically attaching earring posts. Many people don't like relying on glue alone, so they use liquid clay, use UV resin, or embed the posts to reinforce them.

Liquid Clay Spread liquid clay over the earring post and the back of the earring. Press them together, and bake as usual. You also can bake the piece first, spread the liquid clay over the post and back of the earring, then return it to the oven and rebake it for 30–45 minutes.

UV Resin Glue the post to the earring back, and let it dry until the post is firmly set. Then spread a small amount of UV resin over the post and back of the earring. Stick them together, and place the earring under a UV lamp for the amount of time designated by the resin brand's instructions (for more information, see Resin, page 26).

Embedding Press the post into the raw clay on the back of the earring. Then roll out an extra-thin layer of clay, and sandwich the post between the new layer and the earring. Cut away any extra clay.

Techniques for Finishing

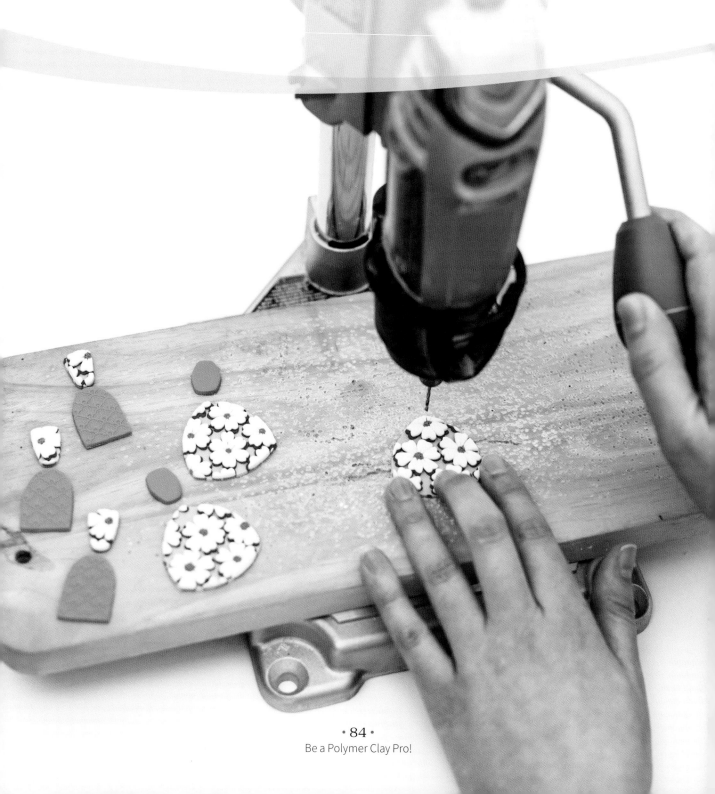

Creating a design is the fun part; finishing a design is the tedious part. But all the work you put into finishing your piece is what will give it a polished, professional look. It's worth doing! For more information about finishing things up, see Finishing Products (page 22).

Sanding

Sanding is one of the most important components of creating a polished finish. Cleaning up or rounding edges will instantly transform a piece. Sometimes sanding is all you need to do. Be aware of how sanding will affect designs and patterns on your clay. You can even sand away smears or imperfections in the design.

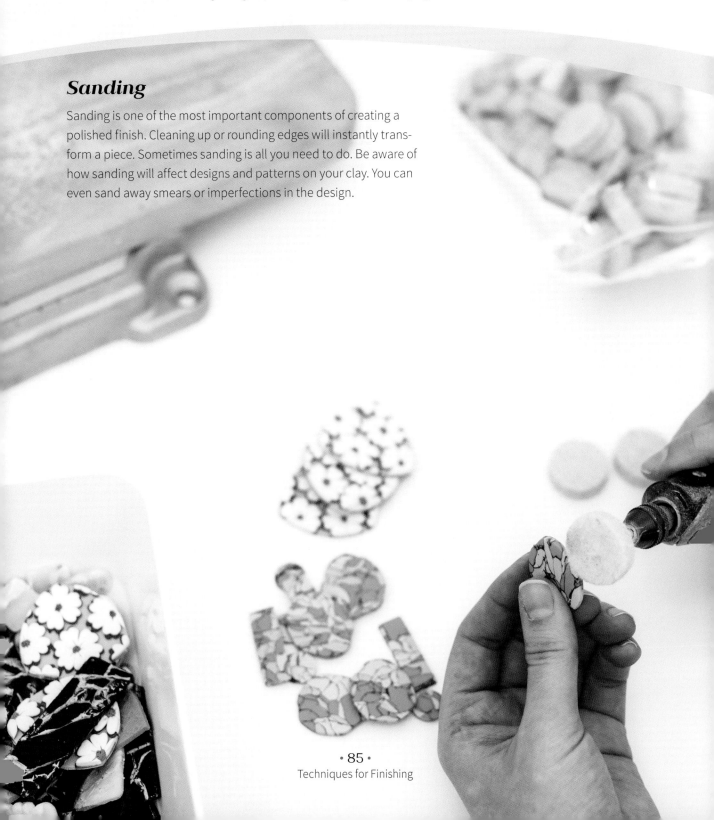

Be a Polymer Clay Pro!

Wet/dry 400- to 800-grit sandpaper is great for sanding by hand. A sanding block is also a good option. The fastest and easiest way to sand is with a handheld power drill. I use a Dremel, but you can use any brand. Choose a small one that fits easily in your hand, and purchase a fitting felt polishing and buffing tip.

If you've never used a power tool before, get a bunch of scrap pieces of clay, and start practicing. Experiment with angles and speed until you're confident in your ability. You should always wear a mask and safety glasses while sanding. After you sand, there is going to be a lot of dust on your pieces. I prefer to use a large soft brush to dust my pieces instead of rinsing them in water.

PRO TIP If you live somewhere with no outside space and don't want dust all over your place, there are a couple things you can do.

- Purchase a grinding box. It's a box that opens on the top and has holes for your hands and drill to go through. You can sand everything inside the box to contain all of the dust. I found mine on Amazon.

- Make your own grinding box. Get a clear plastic bin. The top should be just big enough for a clear garbage bag to fit snugly over it. After you cover the top, cut two holes in the garbage bag for your hands. Place the clay and drill inside the box, and tip the box on its side so you can see. Start sanding. Clean it out and replace the garbage bag as needed.

Drilling

You need to drill holes in your pieces for things like jump rings and ropes or wires. It is always best to drill holes after baking. Putting a hole in a piece while it's raw will distort it. It's nice to have a couple drill bit sizes on hand, but you will mostly want the $\frac{1}{16}''$ size.

You can drill holes by hand or use a power drill. Just like with sanding, if you've never drilled anything with a power tool, gather those clay scraps and practice, practice, practice. Never drill too close or too far from an edge. Too close, and you risk the holes' breaking open. Too far, and the jump ring won't be able to close all the way. It sounds intimidating, but the more you practice and test, the more you'll get a feel for where you should drill.

PRO TIP: WHEN TO SEAL

We've talked about sealing clay throughout the Techniques for Finishing section. Let's summarize:

- Polymer clay without any additives never *has* to be sealed. I usually choose not to seal after using ink pens or silk screens.

- I recommend sealing in glitter, mica powder, paint from paint pens, gold leaf, bottled ink, and hand-painted elements.

- There are always exceptions! You might choose to seal plain clay to give it a glossy, resin look. Or you may choose to not seal in an additive if you know the project won't be touched or used regularly, for example, a sculpture. Each project will be different.

PROJECTS

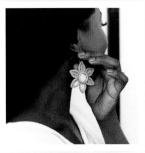
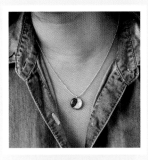
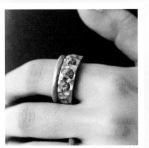
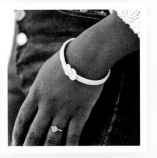
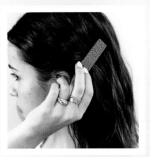
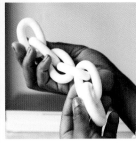
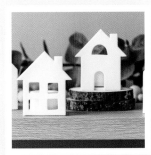

Jewelry

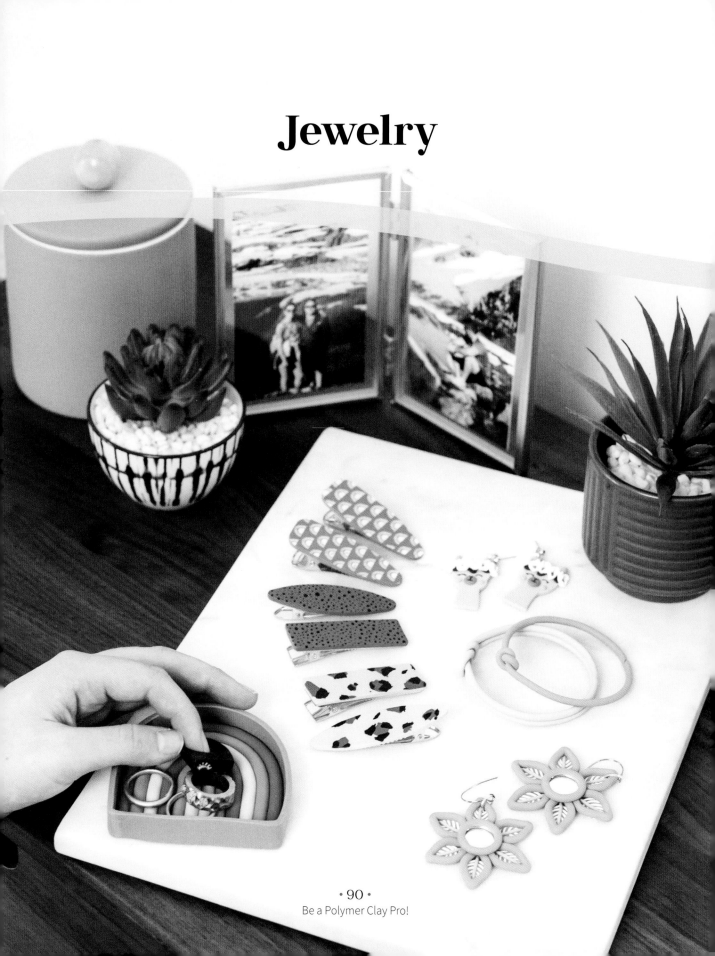

Be a Polymer Clay Pro!

Jewelry is the trendiest and most common way to use polymer clay. I love making jewelry! It gives me so much joy to create pieces of art that people get to carry around with them.

When making jewelry, keep in mind that people will be handling the pieces far more than a piece of art that sits on a shelf. Be mindful of having parts that stick out too much or pieces that might break off with normal wear and tear.

I'm going to demonstrate some different projects using the techniques I've shown you, but remember all the techniques we covered, and mix and match them to see what you come up with! Through these projects, I hope I can inspire and encourage you to let your creativity run wild!

CLAYS USED IN JEWELRY PROJECTS

If you'd like to use the same clay brands and recipes that I use in this project, please refer to this list. But remember that you can always use whichever colors and recipes you'd like to make these projects your own! Learn more about mixing clay in Color Mixing (page 38).

> ### *Black and White*
>
> I like to mix my white and black from two different brands, but you can always just use one brand.
>
> • White: 1pt Souffle Igloo / 1pt Premo White
> • Black: 1pt Souffle Black / 1pt Premo Black

Mirror Earrings, *page 96*

• Dusty Rose: 1pt Souffle Cinnamon / 1¾ pt Fimo Sahara

• Pale Dusty Rose: 5pt Fimo Sahara / 1pt Souffle Cinnamon / 1pt white

Llama Earrings, *page 92*

• Light brown: Fimo sahara

• Dark Brown: 1 pt Sahara / ½ pt Premo Burnt Umber

• Dark Green: 1 pt Premo Forest Green / ⅛ pt black

• Pale Pink: 2 pt Sahara / ½ pt Cinnamon / 2pt white

• Yellow: 2½ pt Fimo Ochre / ½ pt Souffle Pumpkin / ¼ pt Premo Raw Sienna

Pendant, *page 100*

• Premo Navy Blue

Ring, *page 104*

• Premo Turquoise

Bracelet, *page 108*

• Blue: 1pt Souffle Bluestone / 1½ pt white

Llama Earrings

I love to create flat animals to use in my designs for jewelry and home decor. Over time and with practice, you'll develop your own unique style. Make your animals as realistic or fantastical as you like!

MATERIALS

Light brown polymer clay

Dark brown polymer clay

Green polymer clay

Light pink polymer clay

White polymer clay

Yellow polymer clay

Llama cutter (mine is from Hobby Lobby)

Alcohol ink pen

PAC-PEN with petal tip or tiny cutters

Roller and depth guides **or** pasta machine

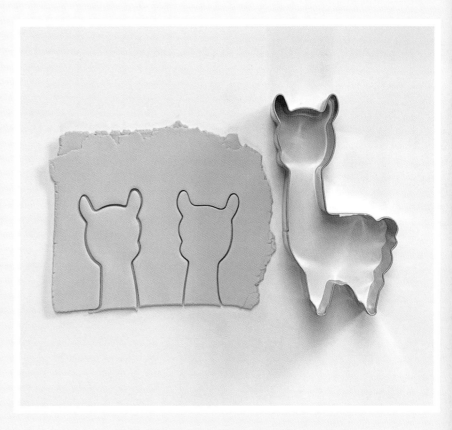

Roll out a slab of the light brown clay to 2mm depth, and cut out a llama using the cutter. You need to cut out only the head of the llama.

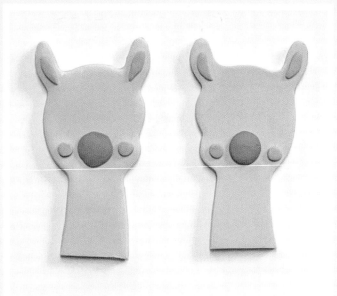

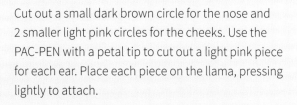

Cut out a small dark brown circle for the nose and 2 smaller light pink circles for the cheeks. Use the PAC-PEN with a petal tip to cut out a light pink piece for each ear. Place each piece on the llama, pressing lightly to attach.

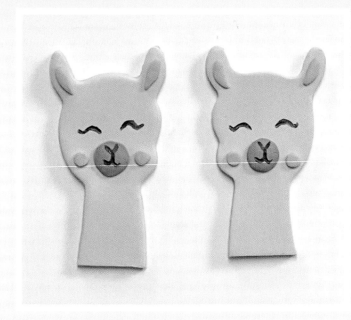

Draw the eyes and nose on the llama with the alcohol ink pen as pictured. Feel free to draw your own expressions! Don't press too hard with the pen, as you don't want to leave indentations in the clay.

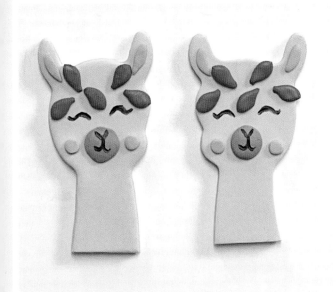

Use the PAC-PEN to cut an assortment of leaves and petals. Lay the leaves down across the llama's forehead.

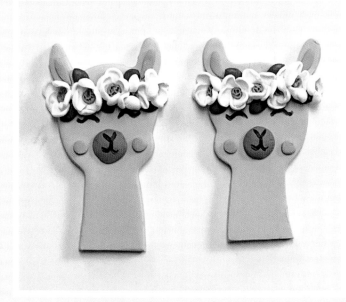

Create a flower from 5 petals. Press the flower onto the llama, then add the flower center. Add flowers across the forehead to create a flower crown. Bake the earrings.

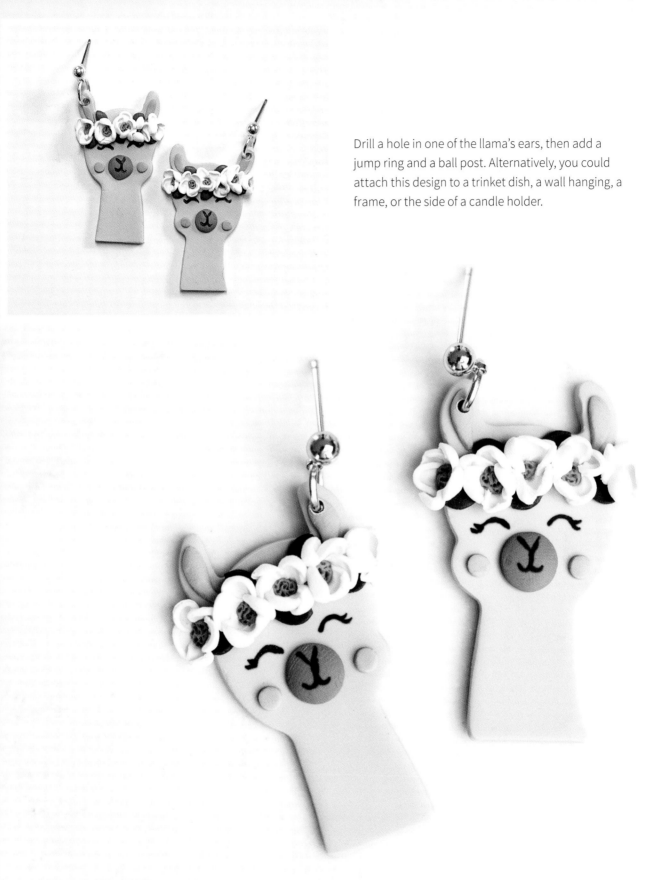

Drill a hole in one of the llama's ears, then add a jump ring and a ball post. Alternatively, you could attach this design to a trinket dish, a wall hanging, a frame, or the side of a candle holder.

Mirror Earrings

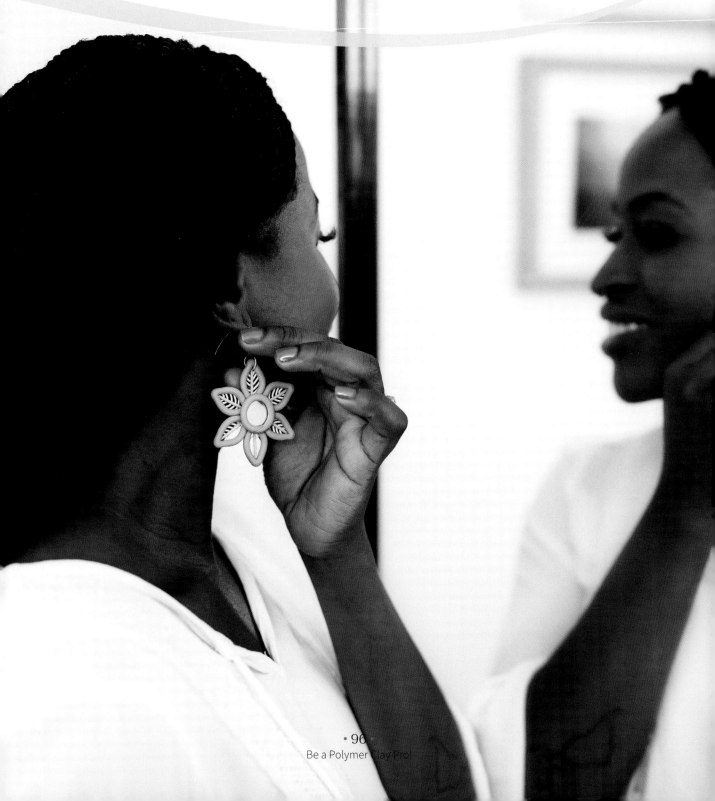

MATERIALS

Pink polymer clay

Light pink polymer clay

White polymer clay

Extruder

½″ (1.2cm) round mirrors

Rubber-tipped blending tool

8mm jump ring

Dangling earring hook

Pliers

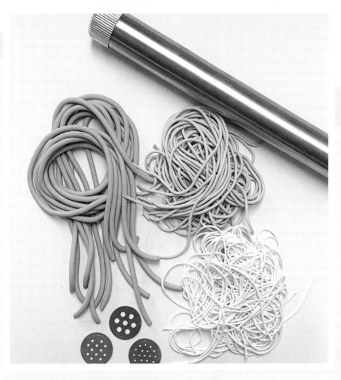

Extrude a rope of the darker pink clay using a large, round disk. Then, extrude the light pink clay using a medium-sized round disk. Finally, extrude the white clay using an extra-small round disk.

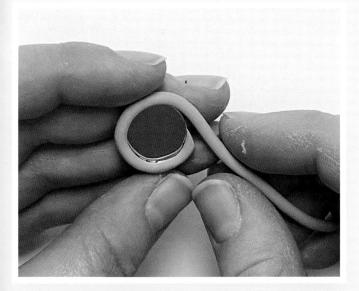

Wrap the dark pink rope all the way around the edge of the mirror. Press the clay against the mirror lightly so it sticks.

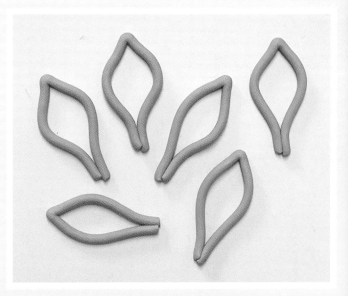

Form 6 petals by hand using the dark pink rope. Cut the rope into a 2″ (5.1cm) piece, then make a slight teardrop shape. Pinch the wider side into a point. Press the two ends of the rope lightly together.

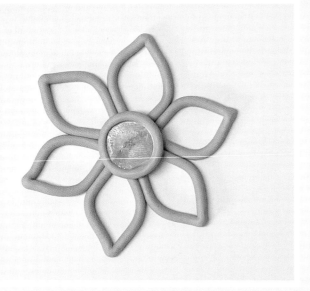

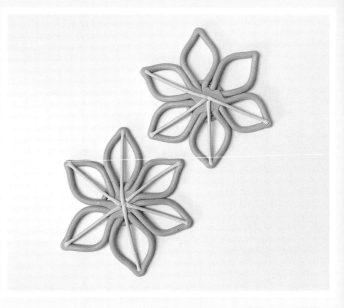

Join all the petals together behind the mirror, placing the mirror in the center. Lightly press the petals against each other. Flatten the bottom of each petal against the mirror to cover the back of the mirror in clay.

Flip the piece over. Cut pieces of the light pink rope to the length of each petal. Place a line of the light pink rope down the middle of each petal.

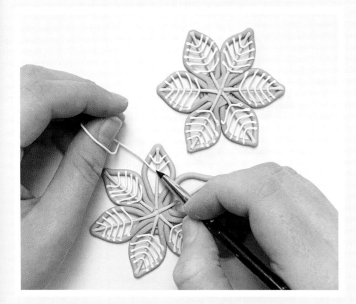

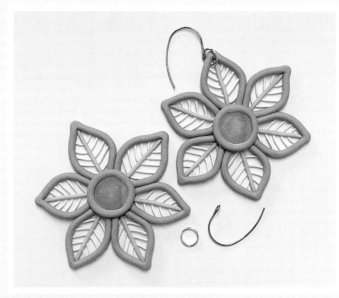

Cut the white rope into pieces approximately ¾" (1.9cm) long. Place the extra-small ropes in a V shape going up each petal. Use the rubber-tipped tool to shape and attach each line. Lightly press each V where it attaches to the petals. Do this five times on each petal.

Flip the piece over. Adjust to make sure each petal is lying flat. Bake as usual. Attach a jump ring around the tip of a petal. Add an earring hook, and close the jump ring.

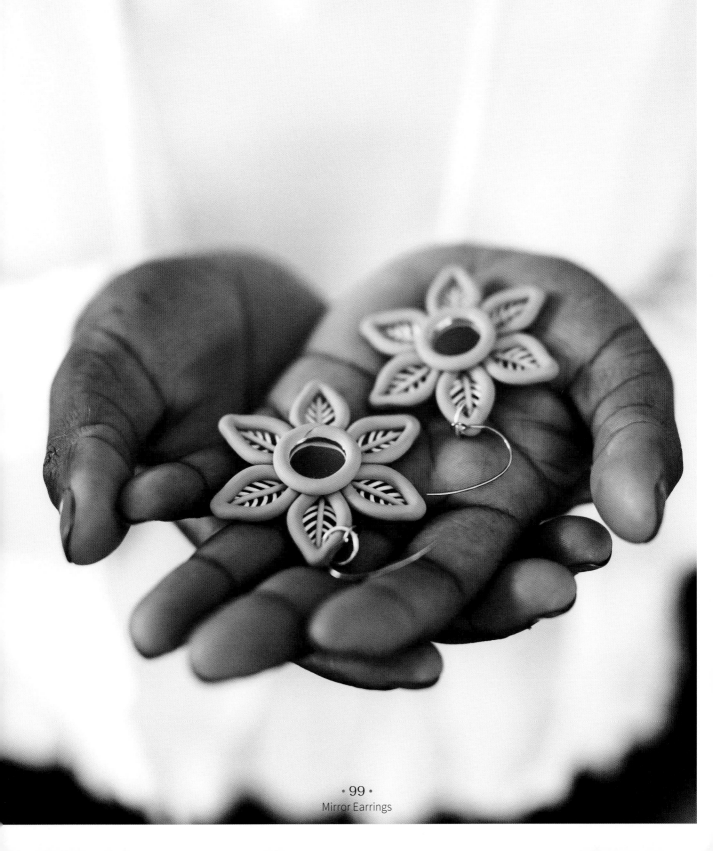

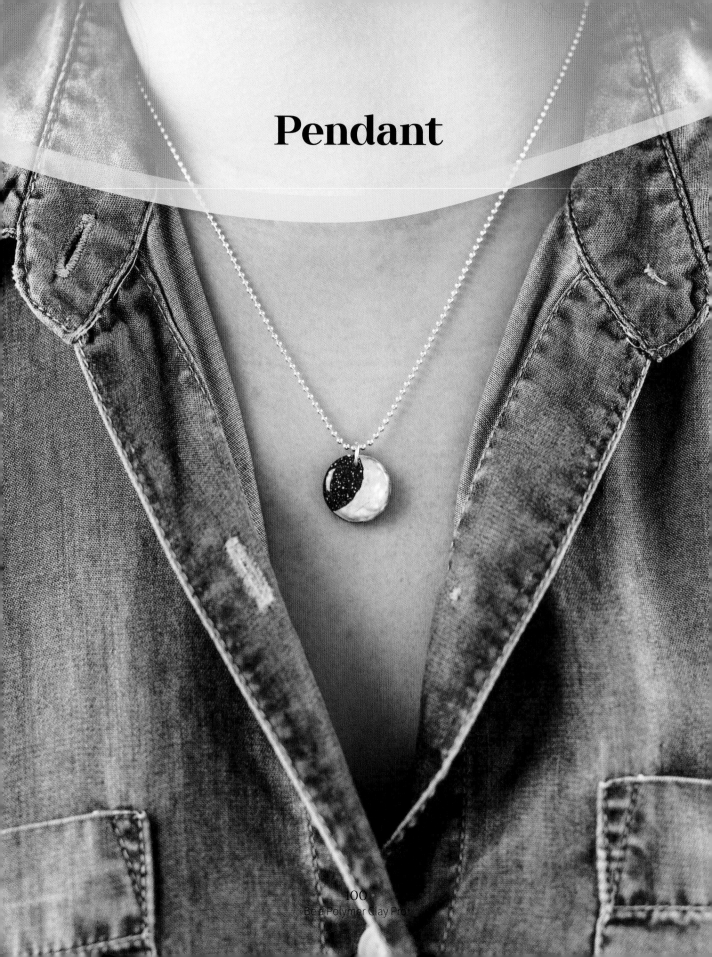

Pendant

MATERIALS

Navy blue polymer clay

½″ (1.2cm) circle cutter

Small moon cutter

White acrylic paint

Ball stylus tool

Toothbrush **or** paintbrush

Roller **or** pasta maker

Silver leaf pen

Resin

Necklace chain

Jump ring

Pliers

Roll the navy blue clay into a 1.5mm–depth slab. Cut out a circle.

Use the curve of the moon cutter to mark a crescent moon shape on the halfway mark of the circle. Do not cut all the way through the circle.

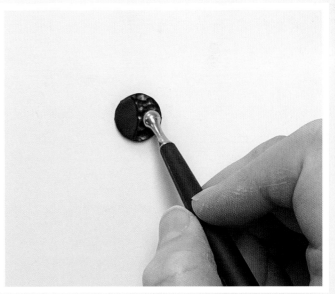

Texture half of the crescent moon shape with your ball stylus. Bake as usual.

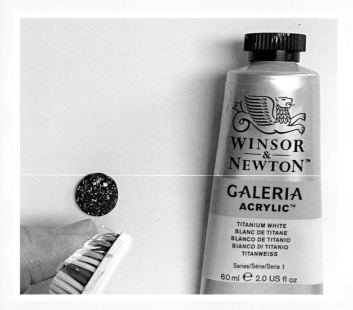

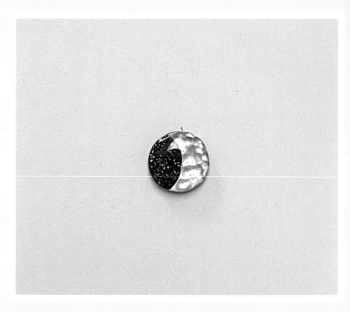

Using a toothbrush or paintbrush, splatter a fine mist of white paint on the circle to represent stars.

Paint the crescent moon (the textured half of the circle) silver with a pen. Cover the whole circle with resin (for more information, see Resin, page 26).

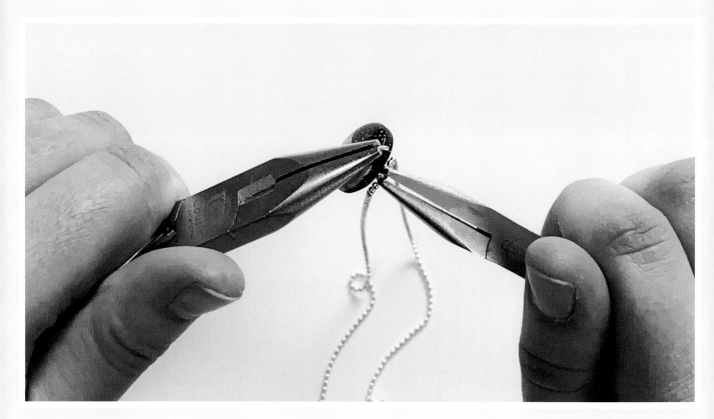

Once the resin is fully cured, sand the edges smooth. Drill a 1/16 mm hole at the top of the pendant. Attach a jump ring. Then add a necklace chain to complete the pendant project.

Be a Polymer Clay Pro!

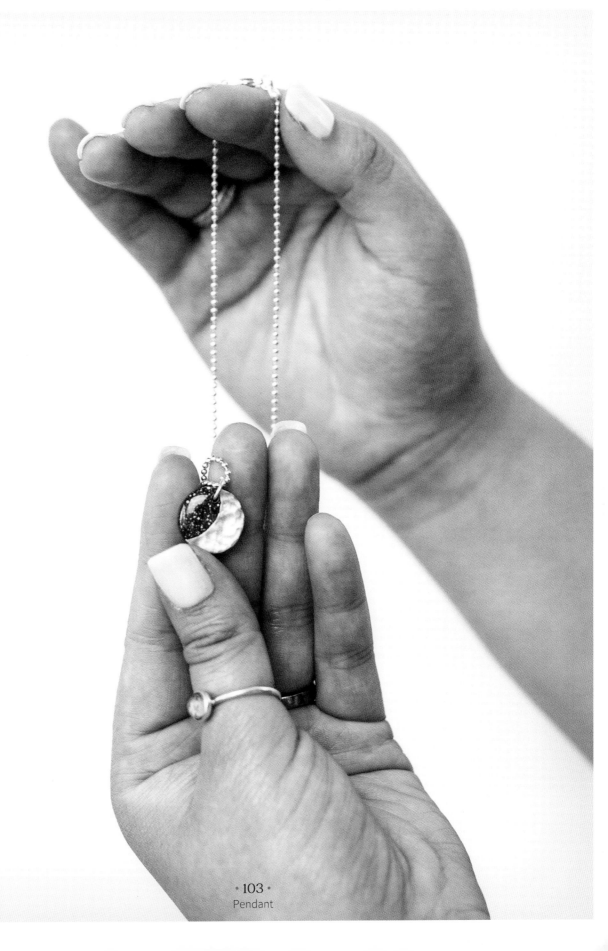

Pendant

Ring

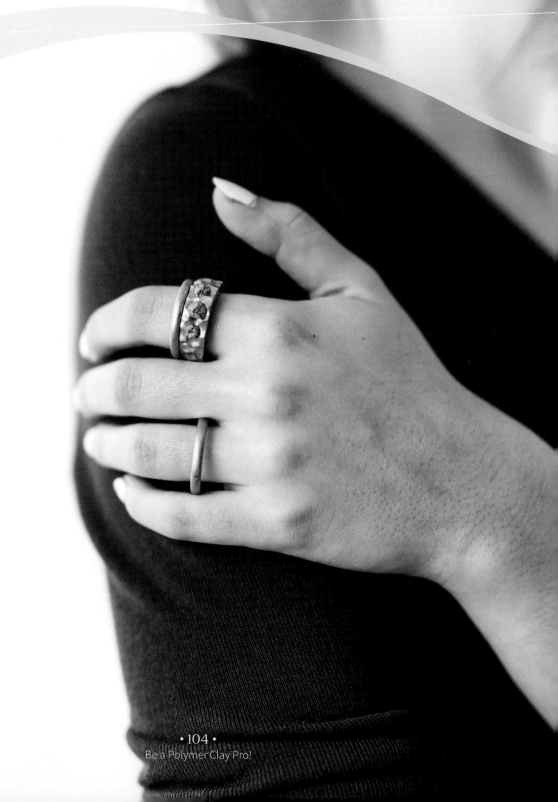

We are going to make a ring entirely out of clay. It's very important that the band is sturdy enough to survive a hand in motion. Polymer clay is sturdy, but clay rings will not stand up to constant daily wear the way metal rings will. Keep this in mind!

For a ring that can withstand more wear and tear, an option is to buy a ring blank, which gives your clay a sturdy base. If you're using a ring blank, you must glue the clay securely to the metal after baking.

MATERIAL

1 color polymer clay

Turquoise "stone" polymer clay

Metal circle cutter the size of your finger **or** a metal ring sizer

Blade

Ball stylus tool

PAC-PEN with two small circle tips

Gold leaf paint pen

Sealant

Roller **or** pasta maker

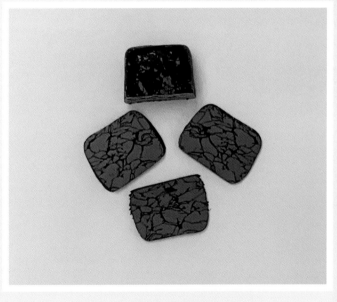

Following the instructions for making "stone" (for instructions, see Creating Patterns, page 64), use turquoise-colored polymer clay and black paint to make clay that looks like turquoise stone.

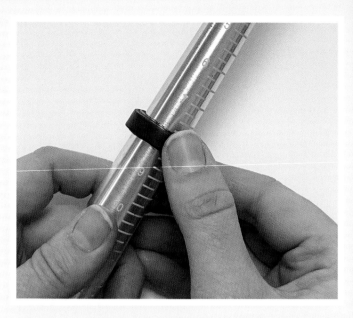

Roll out a slab of the base color clay, and cut a rectangular strip that is long enough to encircle the ring sizer or circle cutter.

Wrap the strip around the cutter or sizer, cut off any excess, and blend the ends of the clay piece together.

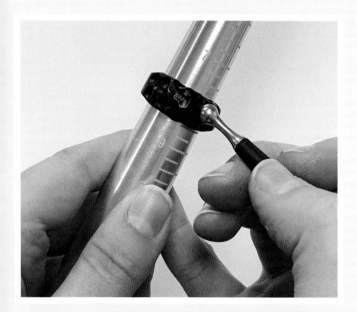

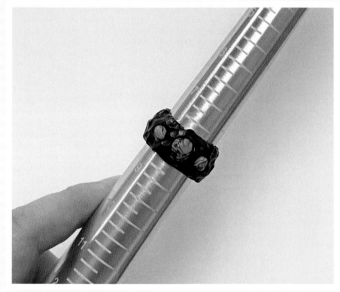

Texture the band of clay with the ball stylus until it looks like hammered metal.

Use a small circle cutter tip with the PAC-PEN to cut out a piece of the band where the turquoise "stone" will go. Fill the circle with a piece of the prepared turquoise stone clay. Repeat this around the band, adding "stones" of different sizes.

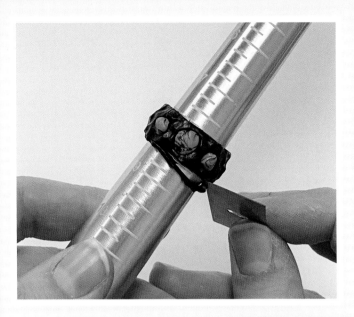

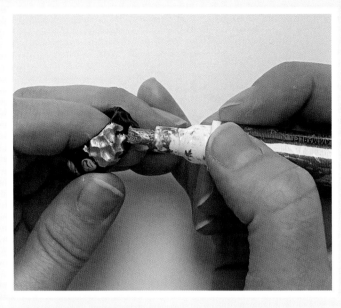

Trim the sides of the band with the blade so they are even.

Bake the ring as usual on the metal sizer or cutter. Remove the ring after it cools, and if needed, sand the sides to make them even. Paint the hammered portion of the ring gold, and apply your sealant of choice. I used Holloway House Quick Shine floor finish.

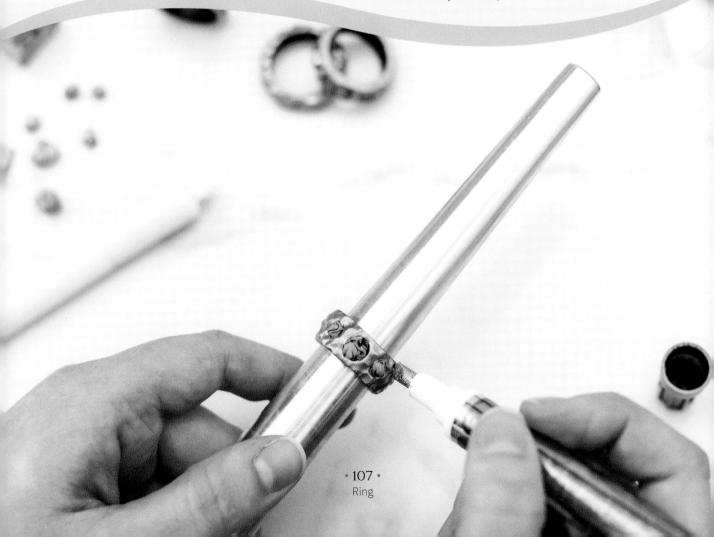

Bracelet

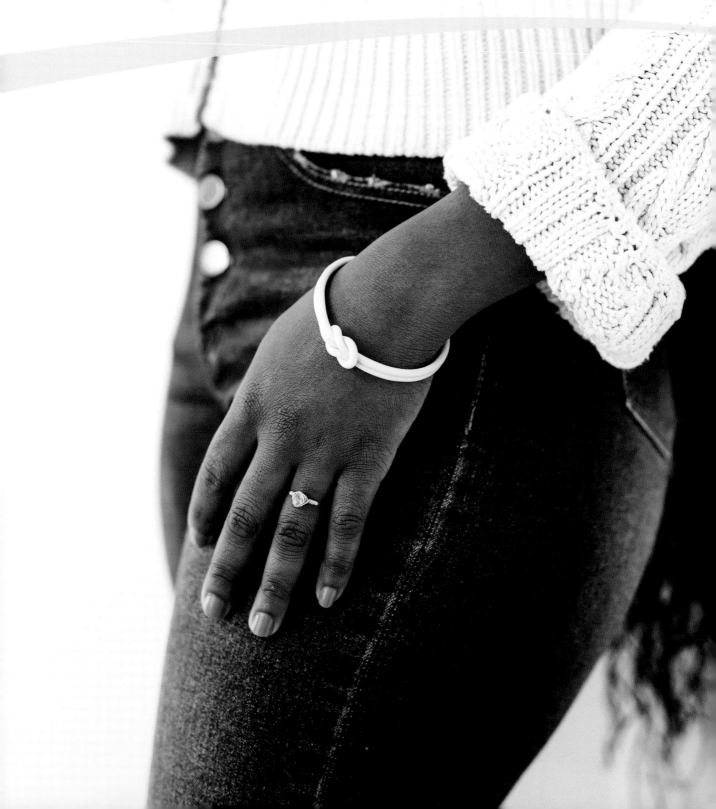

We are going to make a bracelet entirely out of clay, but just like rings, bracelets can be made with metal blanks for more structure.

MATERIALS

Light blue polymer clay

Extruder

Metal circle cutter a little smaller than your hand can fit through

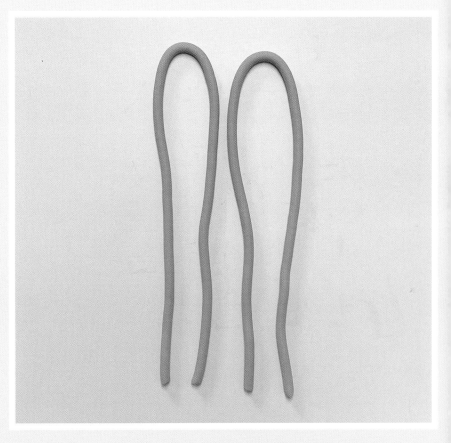

Extrude 2 long, even lines of clay at ¼″ thickness, and fold them in half. Make sure the clay is well conditioned but not too soft or sticky.

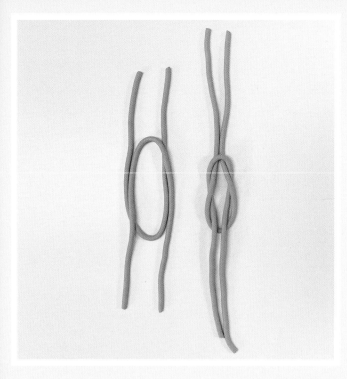

Place the round ends of each piece on top of each other so they look like overlapping 'U's pointing in opposite directions. Then create a knot by feeding the ends of each piece through opposite loops.

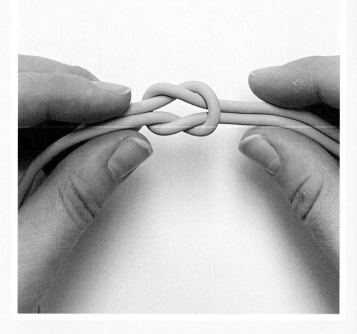

Very carefully and very gently slide the loops closer together. Don't pull on the ends; work on the clay closest to the knot. This will not work if you are using sticky or soft clay.

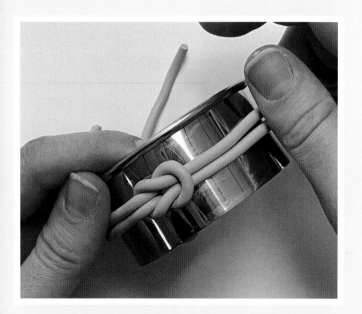

Wrap the bracelet around the metal cutter, and cut off any excess past where the two ends meet. Blend the ends together.

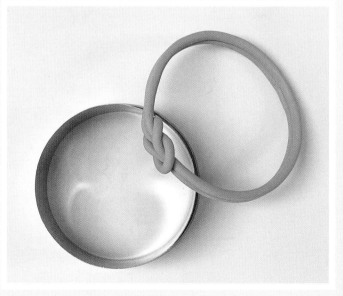

Bake the bracelet as usual, still wrapped on the cutter. When cool, remove the bracelet from the cutter, and sand or clean up as needed.

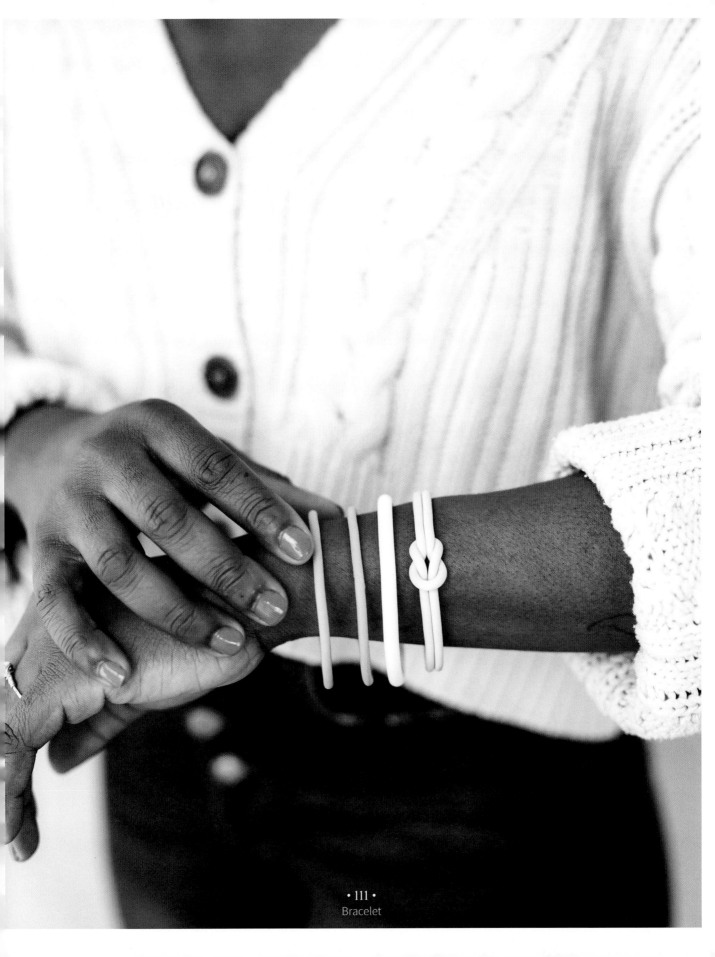

Hair Clips

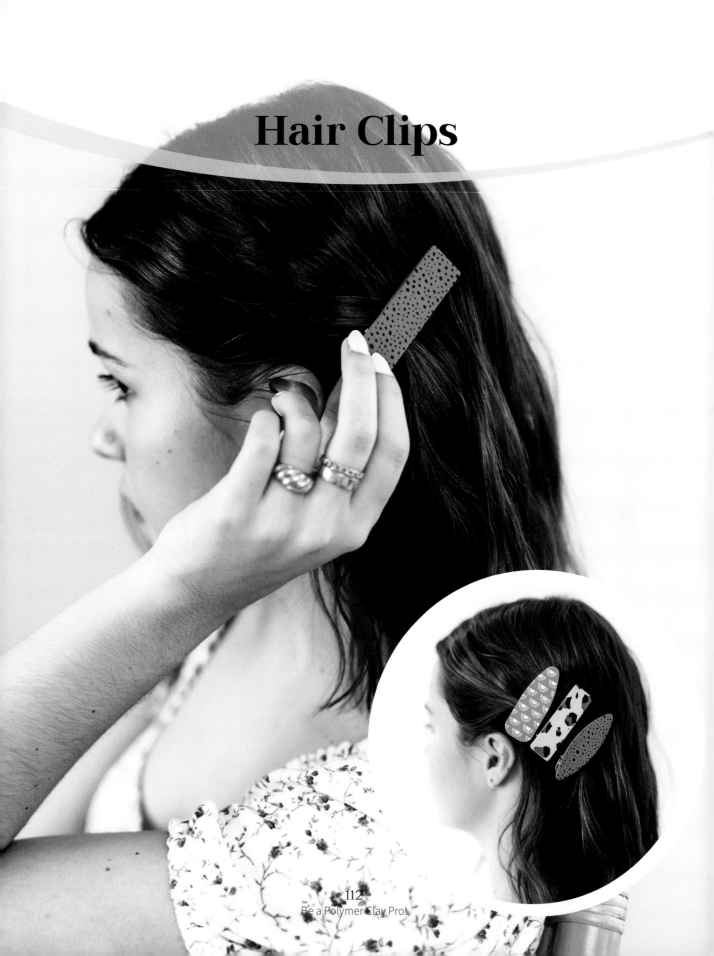

MATERIALS

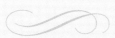

Cinnamon-colored polymer clay

Oval or rectangular barrette-size cutter

Barrette blank finding

Patterned silk screen (pictured: Boho Sun from Ro Clay Co)

Plastic scraper

White acrylic paint

Gel Super Glue

Roller and depth guides **or** pasta maker

Roll a slab of cinnamon polymer clay to 2mm depth. Using the silk screen method (for instructions, see Painting Polymer Clay, page 76), create a pattern on the clay.

After the paint dries, cut out the barrette shapes.

Bake the barrettes as usual, and once cool, sand the edges. Add a sealant if you prefer. For this project, I did not seal the barrettes. Glue the clay to the barrette finding.

Home Decor

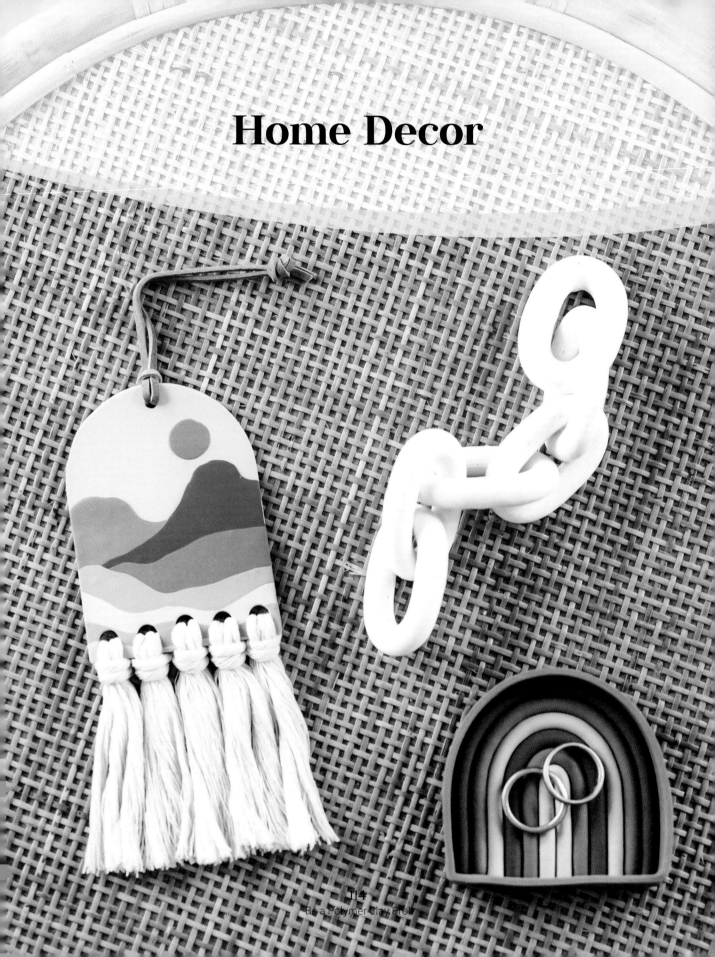

Making jewelry with polymer clay might be my favorite thing, but polymer clay is also an exciting medium to use for small home decor. It can add that special personal touch!

CLAYS USED IN THESE PROJECTS

If you'd like to use the same clay brands and recipes that I use in this project, please refer to this list. But remember that you can always use whichever colors and recipes you'd like to make these projects your own! Learn more about mixing clay in Color Mixing (page 38).

> ### Black and White
>
> I like to mix my white and black from two different brands, but you can always just use one brand.
>
> - White: 1pt Souffle Igloo / 1pt Premo White
> - Black: 1pt Souffle Black / 1pt Premo Black

Coffee Table Sculpture, *page 116*

- Speckled: 2pt white / 1 pt Premo Granite

Tea Light House, *page 118*

- White

Decorative Jar, *page 120*

- Blue: Premo Pale Blue
- Yellow: Souffle Canary
- Green: 1pt Fimo Leaf Green / ¼ pt black

Incense Holder, *page 124*

- Fimo Sahara
- White

Candle Holder, *page 126*

- Mustard Yellow: 2½ pt Fimo Ochre / ½ pt Souffle Pumpkin / ¼ pt Raw Sienna

Wall Hanging, *page 130*

- Light Brown: Fimo Sahara
- Mustard Yellow: 2½ pt Fimo Ochre / ½ pt Souffle Pumpkin / ¼ pt Premo Raw Sienna
- Red: Souffle Cinnamon
- Orange: 2pt Pumpkin / ⅛ pt Premo Burnt Umber
- Dusty Rose: 1pt Souffle Cinnamon / 1¾ pt Fimo Sahara
- Pale Pink: 5pt Fimo Sahara / 1pt Souffle Cinnamon / 1pt white

Trinket Dish, *page 134*

- Green: Souffle Sage
- Light Brown: Sahara
- Mustard Yellow: 2½ pt Fimo Ochre / ½ pt Souffle Pumpkin / ¼ pt Premo Raw Sienna,
- Brown Leather: 2 pt Pumpkin / 1 pt Premo Raw Sienna / ⅛ pt Premo Pomegranate

Frame, *page 138*

- Yellow: Fimo sunflower
- Black
- Green: 1 pt Fimo Leaf Green / ¼ pt black

Coffee Table Sculpture

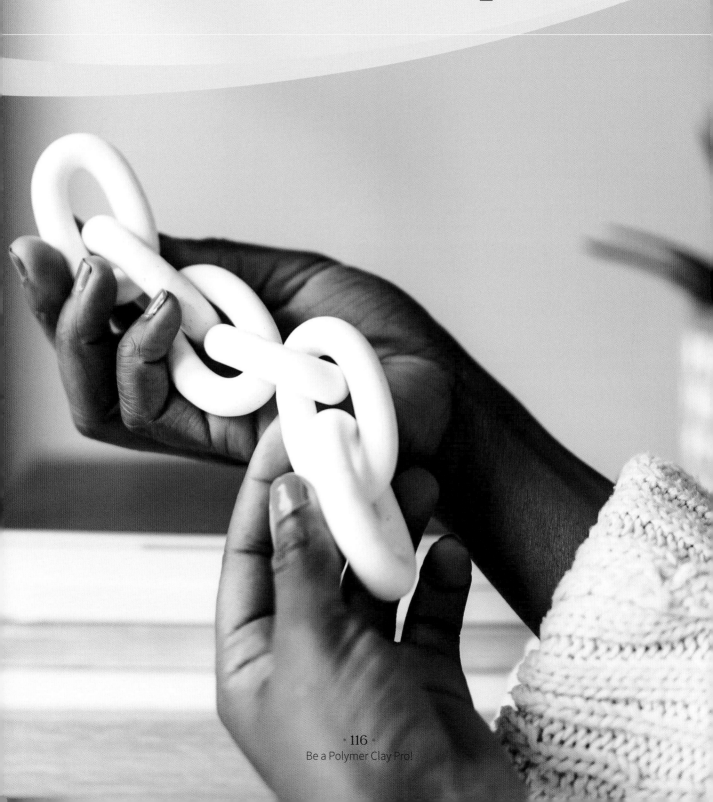

Be a Polymer Clay Pro!

MATERIALS

White speckled polymer clay

Extruder

Extra-large round
extruder discs

Blade

Gel Super Glue

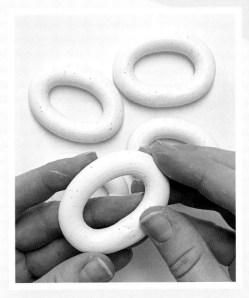

Extrude or hand roll extra-thick
round ropes from the speckled clay.
Cut them into 5″ (12.7cm) lengths.
Make 3–7 ropes.

Shape each rope into an oval, and
blend the ends together until the
seam is gone.

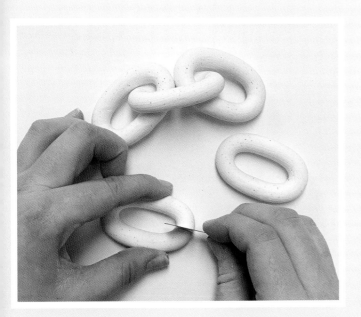

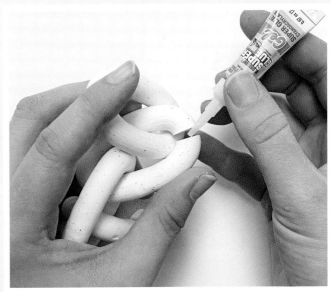

Bake them as usual. Then use the blade to slice one
gap in every other oval. Join them in a chain link.

Glue each oval back whole.

Tealight House

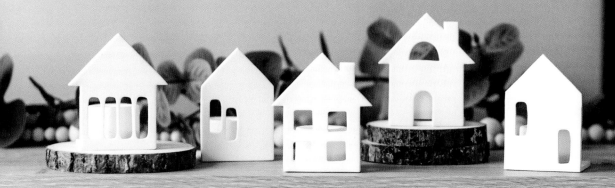

Be a Polymer Clay Pro!

Remember that polymer clay is plastic. It should never be anywhere near an open flame! This design is meant for battery-operated candles only.

MATERIAL

White polymer clay

Craft knife

House-shaped cutter

Small square, circle, or rectangle cutter

Roller and depth guides **or** pasta machine

Gel Super Glue

Roll out the clay to 4mm depth. Measure the bottom edge of the house cutter, and using a craft knife, cut out a square of clay that is the same length. Set aside.

Roll out more clay to the same thickness, and cut out a house. If you don't have a house-shaped cutter, you can freehand it or make a template out of paper to use as a guide. Use a small circle, square, or rectangle cutter to cut out windows.

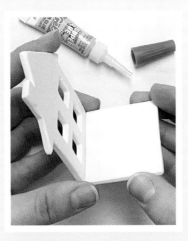

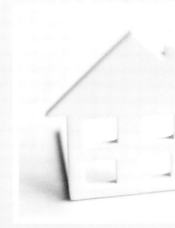

Bake both pieces flat and separated. Sand all the edges.

Rough up the bottom inside edge of the house and one of the square edges. Glue the two pieces together at a 90° angle. Add a battery-operated candle onto the square base.

Decorative Jar

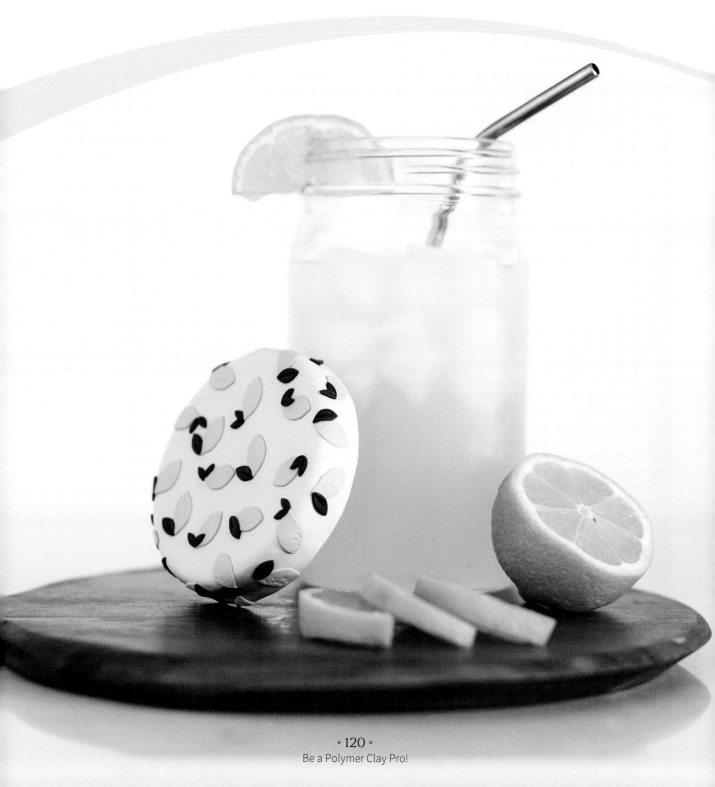

Raw clay is compatible with glass and metal. It easily sticks to both surfaces, and they can be baked in the oven together. To be extra safe, I always let glass completely cool in the oven before I remove it.

MATERIALS

Glass jar with metal lid

Light blue polymer clay

Yellow polymer clay

Green polymer clay

Craft knife

Small lemon-shaped cutter

PAC-PEN with leaf/petal tip

Circle cutter ½″ (1.2cm) bigger than the lid

Needle tool

Small ball stylus

Roller with depth guides

Roll out a slab of blue clay 2mm thick, and cut out a circle that is slightly larger than the lid.

Remove the lid from the jar. Cover the lid with the circle of clay. Press and stick the clay to the metal, and cut off any excess clay from the bottom. Screw the lid back onto the jar to make sure no clay is interfering with the lid.

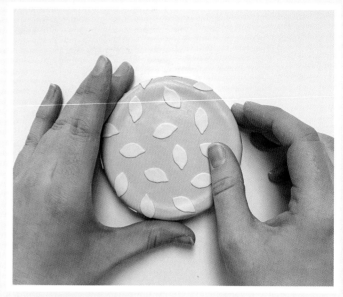

Roll out the yellow clay extra thin. Cut out a number of lemons based on the size of the lid. Clean up the edges of each lemon. Place them on the lid in a random pattern by gently pressing them onto the blue clay.

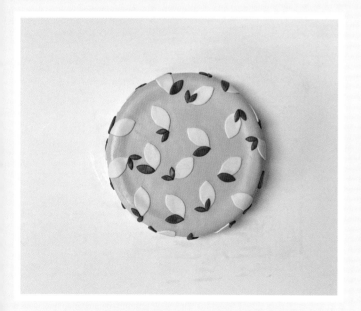

Use the PAC-PEN or craft knife to cut out lemon leaves, and add them to the top of each lemon.

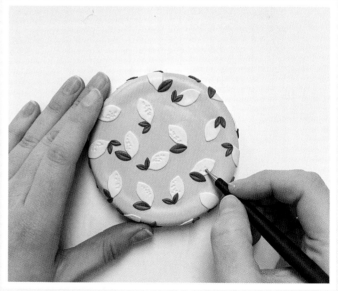

Use the needle tool and ball stylus to add texture to the leaves and lemons. Bake as usual, including the lid.

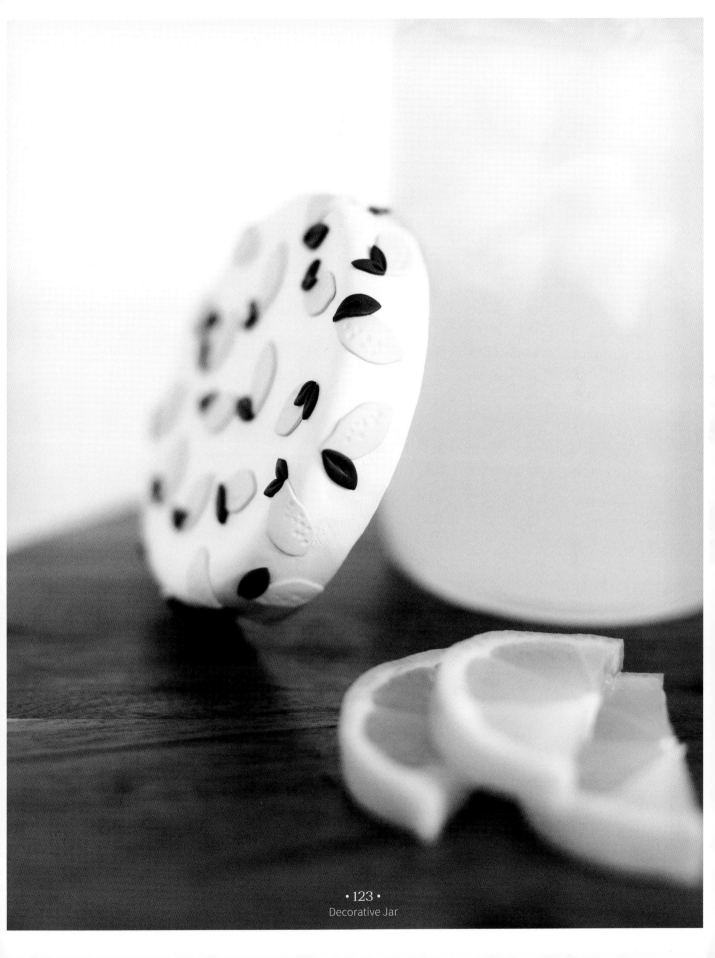

Decorative Jar

Incense Holder

MATERIALS

"Wood" polymer clay (brown polymer clay, brown acrylic paint)

White polymer clay

Roller and depth guide **or** pasta machine

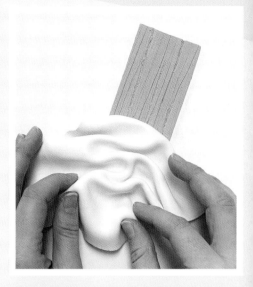

Using the wood pattern technique (for instructions, see Creating Patterns, page 64), create a raw slab of "wood" clay. Cut a long rectangle from the slab that is 6″ × 2″ (15.2cm × 5.1cm).

Roll out the white clay as thin as possible. Drape the white clay like fabric over about ⅓ of the rectangle.

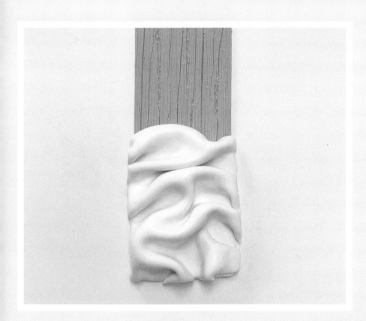

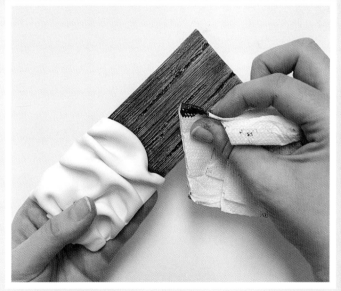

Cut off the excess white clay that does not fit on the rectangle. Using an incense stick, poke a hole into the white clay. Remove the incense, and bake as usual.

Sand the edges as needed. Avoiding the white clay, finish the wood technique by painting and then wiping the wood texture.

Candle Holder

This design is meant for battery-operated candles only! Polymer clay is plastic and should never be near an open flame.

MATERIALS

Mustard yellow polymer clay

White polymer clay

Battery-operated candle

Blade

2″ (5.1cm) circle cutter

Roller with depth guides **or** pasta maker

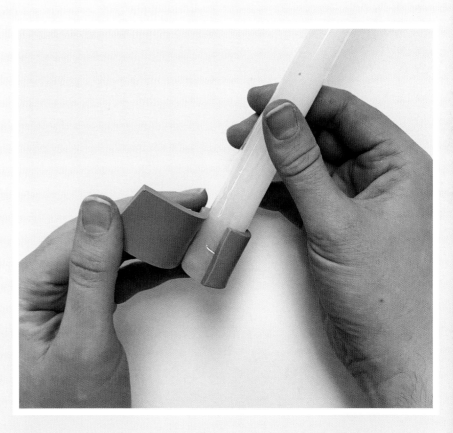

Roll out the yellow clay to 3mm depth, and cut out a 1½″ (3.8cm) strip. Wrap the strip around the bottom of the candle. Cut off excess. If you're worried about the clay sticking, wrap the candle in parchment paper first.

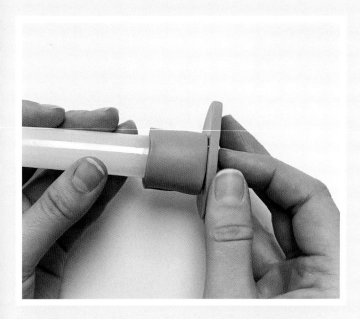

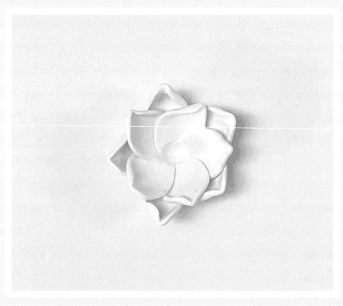

For the bottom part of the candle holder, cut out a 2″ (5.1cm) circle. Join the two clay pieces together by lightly pressing them together.

Using the flower technique (for instructions, see Sculpting, page 41), assemble a flower, but don't add the center yet.

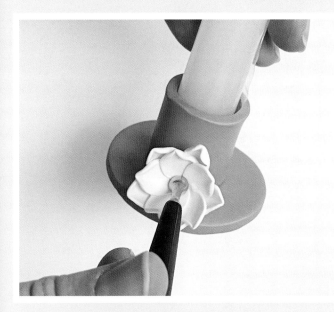

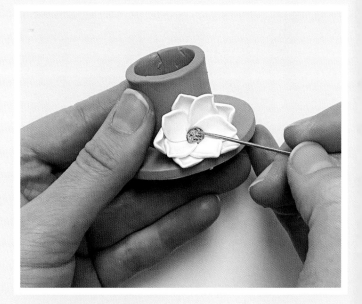

Using a ball stylus, pick up the flower, and press it firmly onto the candle holder. Add a drop of liquid clay behind the flower if it's not sticking securely.

Add the yellow to the center of the flower, and add texture. Bake as usual.

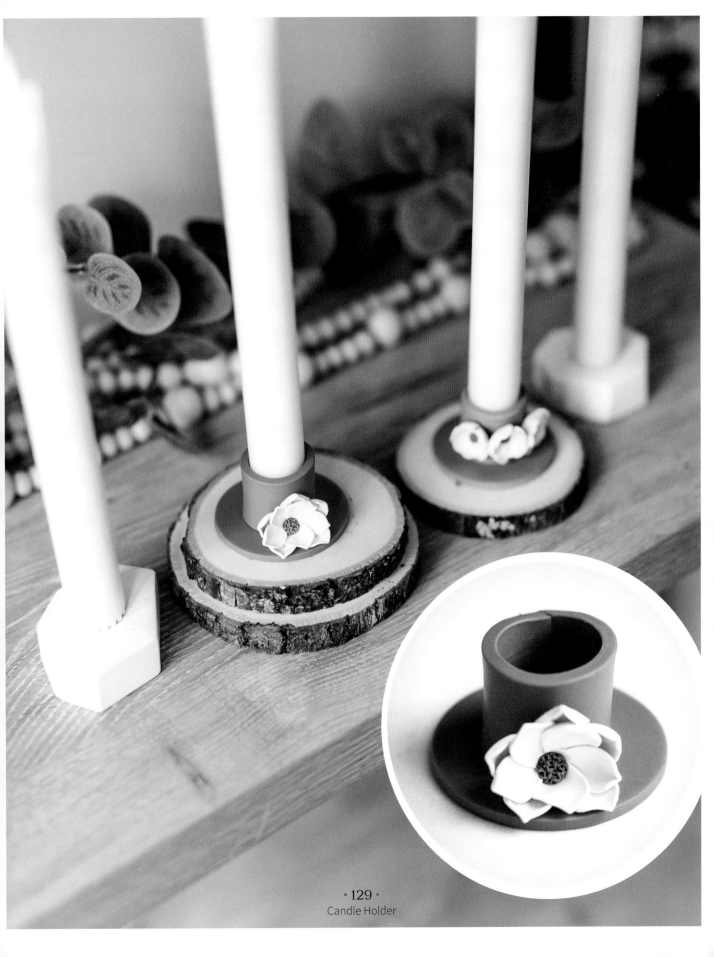

Wall Hanging

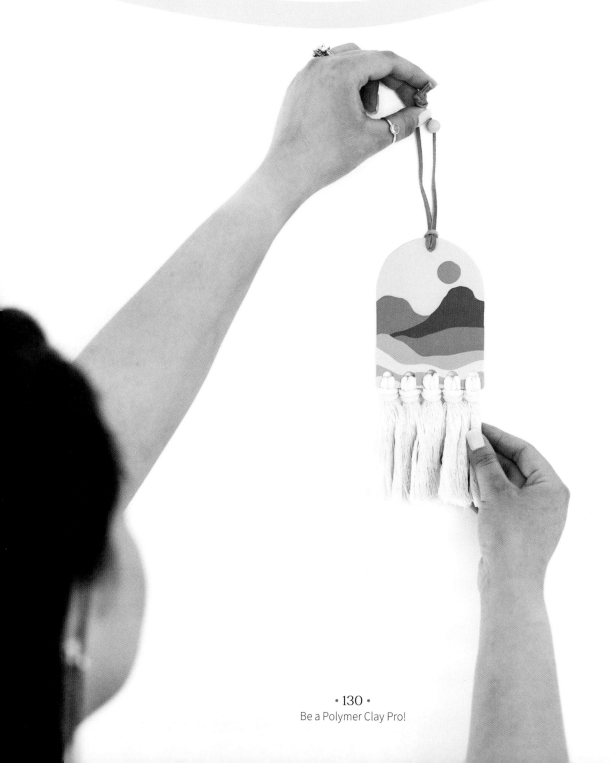

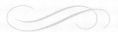

MATERIALS

Desert colors of polymer clay (pink, tan, light tan, yellow, red, and light orange)

Large arch cutter

Craft knife

Small circle cutter

Macrame rope

Alcohol ink pen

Scissors

Roller and depth guides **or** pasta machine

Cord for hanging

Hand drill **or** Dremel

Comb

Roll out the base color, light tan, to 2mm depth. Lightly press the large arch cutter into the clay to outline the shape, but don't cut all the way through yet.

Roll out the remaining colors as thin as possible. Freehand cut a hilly landscape from each layer in a different color using the craft knife. Don't include the yellow clay. You want the pieces to fit together, so use each piece you cut as a loose guide for the next piece.

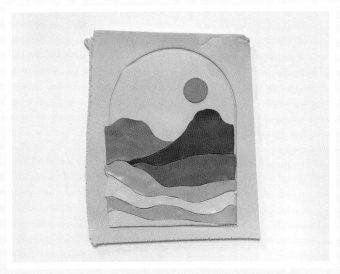

Lay out all the pieces on top of the base. Cut out a yellow circle for the sun, and place it in the sky.

Gently roll everything flat, and then use the arch cutter to cut out the design all the way.

Transfer the piece to the baking surface. Starting in the center, cut holes across the bottom of the wall hanging using the small circle cutter. Make sure not to get too close to the edge. Then bake as usual, and sand the edges as needed.

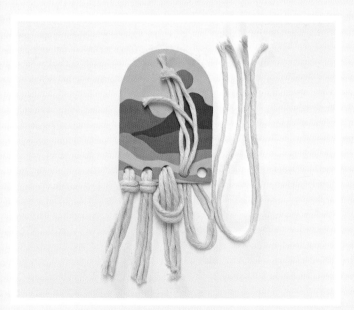

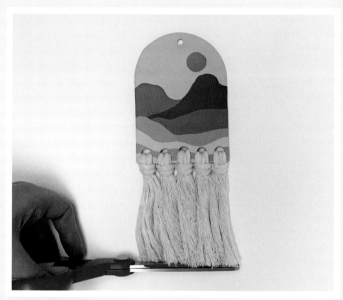

Knot the macrame rope through each hole. Cut the rope into 8″ (20.3 cm) strips. Grab 2 strips, and fold them in half. Insert all 4 ends through the back of 1 hole. Then, pull the 4 ends around the front of the hanging and through the rope loop. Pull snugly.

Trim and comb the fringe. Drill 1 or 2 holes at the top of the wall hanging, and add a cord loop for hanging.

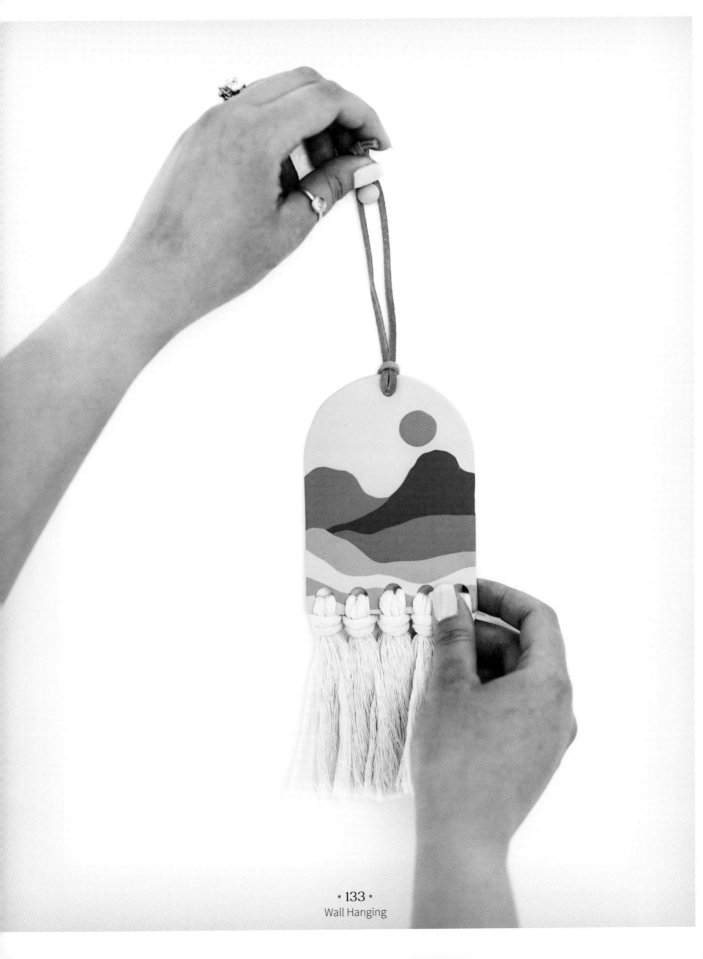

Trinket Dish

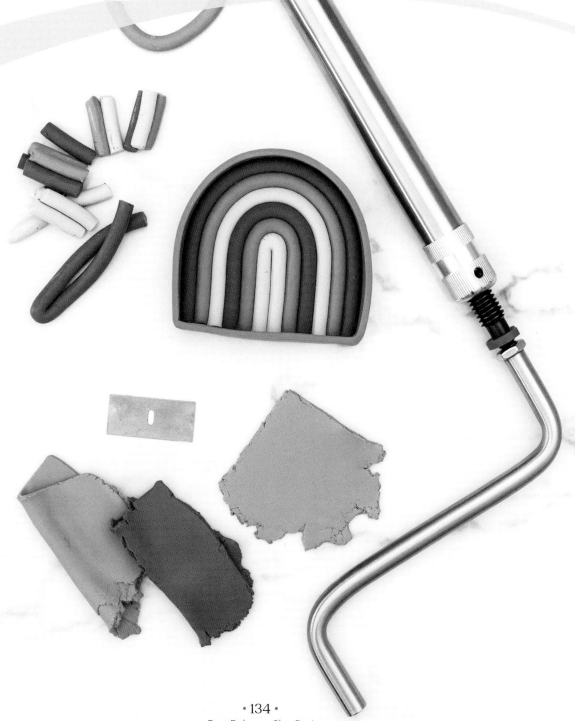

After you create beautiful jewelry, you need an equally beautiful place to store it. Once you master this project, you'll be able to make a custom trinket dish in any shape, size, or color!

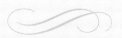

MATERIALS

Light tan polymer clay

Mustard-yellow polymer clay

Reddish-brown polymer clay

Green polymer clay

Extruder

Blade

Roller and depth guide

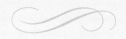

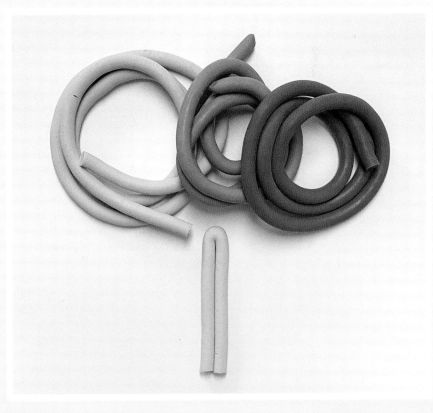

Extrude a long rope of each color with a large round circle disc. Start the rainbow by folding 1 clay rope approximately 2″ (5.1cm) long in half.

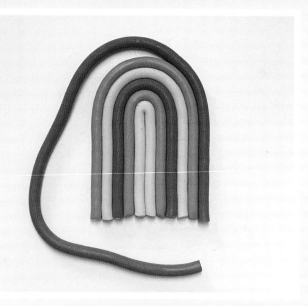

Build the rainbow one rope at a time by arching them on top of each other and gently pressing them together as you go. Trim the bottom edges of the arches to be flat and even, and set aside.

Roll out a thick slab of clay that is long enough to wrap around the rainbow. Cut a strip that is slightly taller than the rainbow, approximately ½″ (1.2cm) wide and still long enough to wrap around the whole rainbow. Use a ruler or paper template to make sure the rectangle is as precise as possible.

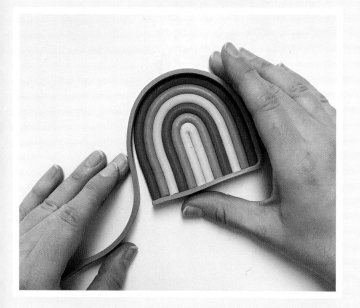

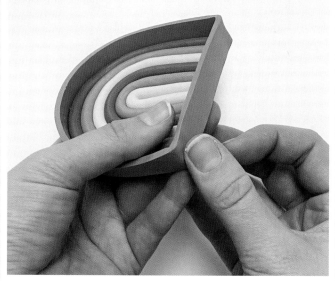

Starting at one of the bottom corners, wrap the rectangle strip around the rainbow. Press it gently on the bottom to help it stick. Try to keep the walls as straight up and down as possible.

Once you get all the way around, use your fingers to blend the corner together. Cut off any excess first, if necessary.

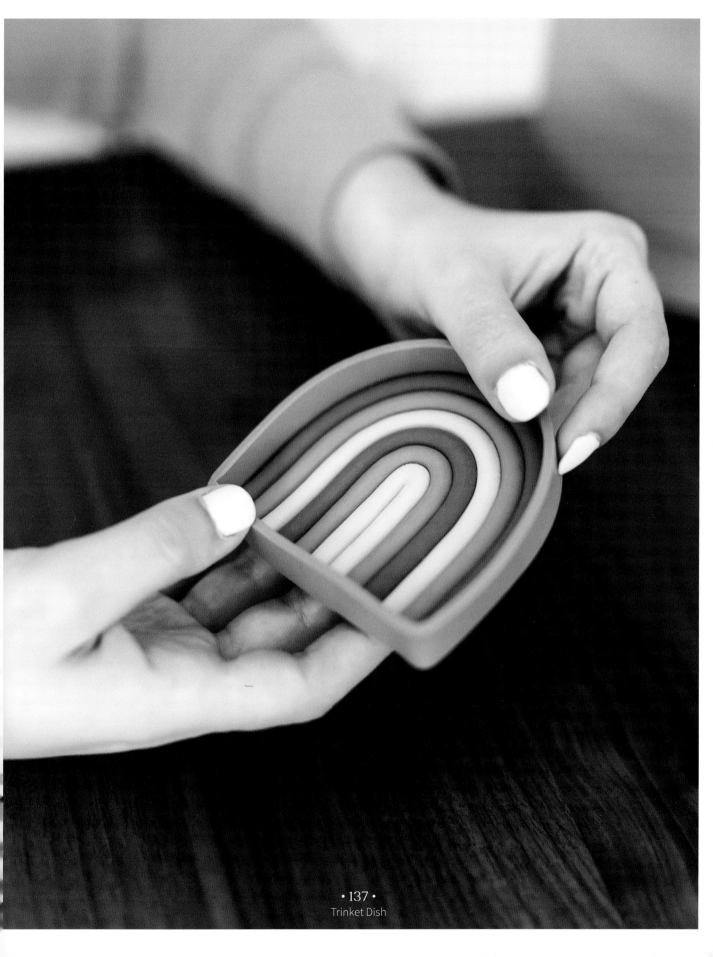

Frame

You can create your own frame completely from clay, but it's much easier to cover or embellish an existing frame. Make sure that if you're covering a frame, you find one with absolutely no plastic that will melt in the oven! Stick to frames that are metal, glass, and wood. If you're just going to add embellishments, you can bake them separately and then add them to a frame of any material.

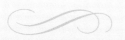

MATERIAL

Black polymer clay

Yellow polymer clay

Green polymer clay

Frame (must be wider than the height of letter cutters)

PAC-PEN with leaf/petal tip

Letter cutters

Roller and depth guide **or** pasta maker

Gel Super Glue

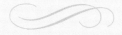

Roll out a slab of black polymer clay to 1.5mm depth, and cut out any word using the letter cutters. Clean up the letters by gently running your fingers along the edges of each one.

Roll slabs of yellow and green clay to 1.5mm depth. Using the PAC-PEN, cut out petals and leaves. Shape some of the petals and leaves into flowers, and leave some loose to spread around the cutout word.

Place the word on the frame to plan how everything will fit. Attach the flowers and leaves to the letters.

Move the letters and flowers to the baking surface. Bake as usual. Clean up edges as needed, and glue all the baked pieces to the frame.

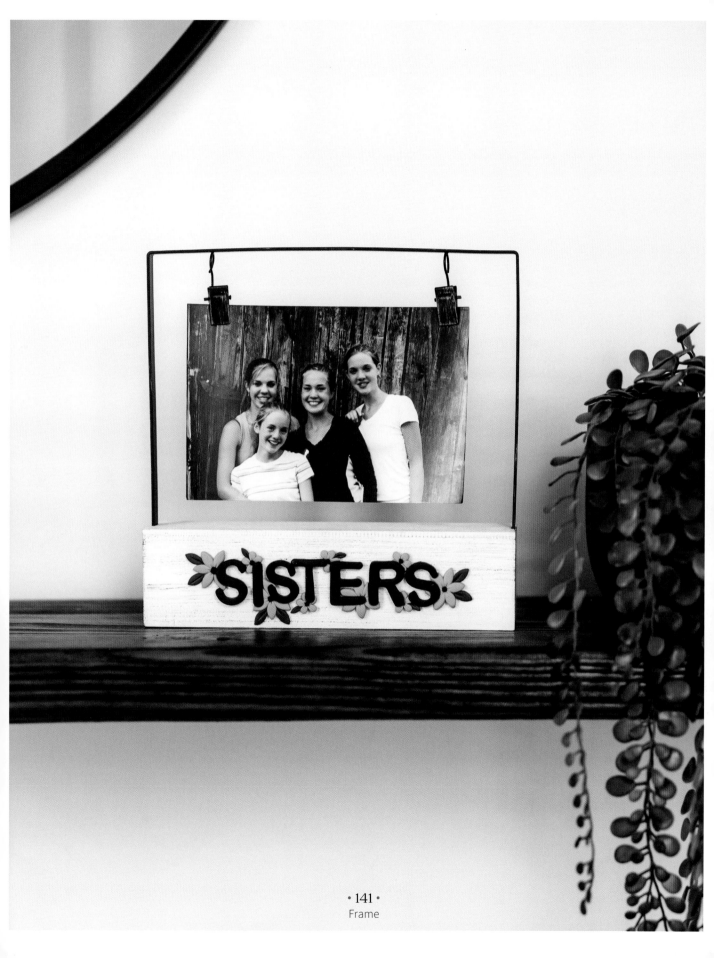

About the Author

Lauren Tomlinson is a U.S.-based artist who has been working with polymer clay for more than twenty years. She discovered it at a sleepover when she was just twelve. While she loves all things creative and DIY, polymer clay has always been her true love. With a lot of love, support, and encouragement, she eventually started her own clay business. Lauren grew up one of thirteen siblings. She has eleven nieces and nephews (so far) and plays volleyball any chance she gets. She loves to travel; her favorite places so far have been Jordan and Australia. She has lived in Rochester, New York, for most of her life. Find Lauren online at ltcreated.com or on Instagram @ltcreated.

Index

CREATIVE SPARK

ONLINE LEARNING

Crafty courses to become an expert maker...

From their studio to yours, Creative Spark instructors are teaching you how to create and become a master of your craft. So not only do you get a look inside their creative space, you also get to be a part of engaging courses that would typically be a one or multi-day workshop from the comfort of your home.

Creative Spark is not your one-size-fits-all online learning experience. We welcome you to be who you are, share, create, and belong.

Scan for a gift from us!

creativespark.ctpub.com